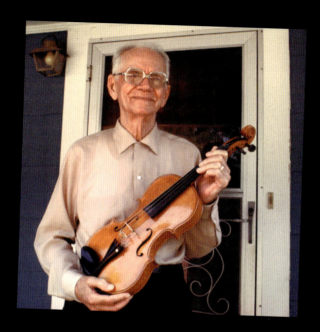

A Chattahoochee Album

Images of Traditional People and Folksy Places
Around the Lower Chattahoochee Valley

Text and Photographs by Fred C. Fussell

Historic Chattahoochee Commission
Alabama and Georgia

Library of Congress
Cataloging-in-Publication Data

Fussell, Fred
A Chattahoochee album : images of traditional people and folksy places around
the lower Chattahoochee Valley / photographs and text by Fred C. Fussell.
p. cm.
ISBN 0-945477-14-7 (paperback)
1. Folklore—Chattahoochee River Valley.
2. Chattahoochee River Valley—Social life and customs.
3. Folklore—Chattahoochee River Valley—Pictorial works.
4. Chattahoochee River Valley—Social life and customs—Pictorial works.
I. Title

GR108 .F87 2000
306'.09758—dc21 00-031950

For further information:
Historic Chattahoochee Commission
of Alabama and Georgia
P.O. Box 33, Eufaula, AL 36072-0033
(334) 687-9755
or
P.O. Box 942, LaGrange, GA 30241-0942
(706) 845-8440

email: hcc1@zebra.net
web site: http://www.hcc-al-ga.org/

Design by afj graphics

Contents

Acknowledgments

Thanks go to my family—Cathy, Matt, Luke, Coulter, Jake—all of whom have endured many periods of waiting around patiently during family trips and vacations while I spent time looking at places, things, and people through my camera. They were more often my vigilant alter-eyes, spotting and reporting items of interest that passed me by. Thanks, y'all, for sharing.

I am appreciative for the kind encouragement and support that was offered to this project by the Historic Chattahoochee Commission and, particularly, by its Executive Director, Douglas C. Purcell. This book was actually Doug's idea in the first place. Doug Purcell is forever and always enthusiastic about creating meaningful things for other people (but also for himself) to do.

Thanks go to my friends, relatives, and colleagues who share an interest in the traditional culture of the Deep South and that of the Chattahoochee Valley, and who often provided tips, information, and directions leading to things and people of interest in the region. This list includes John Lupold, Billy Winn, Joey Brackner, Hank Willett, Steve Grauberger, Tim Chitwood, Virginia Causey, Butch Anthony, Frank Turner, Anne King, Mac Moye, Henry Lynch, Jr., everyone who's a part of the Hall Bunch, George and Cathy Mitchell, Frank Schnell, Bobby and Snooky Williams, Deborah Shaw, Janice South, Anna Jacobs Singer, and the late Joe Mahan. I know there are others, and I'm certain their names will come to mind after it's too late to include them. I am also indebted to the institutions with which I've worked over the years. They provided many entrees and opportunities to delve into the topic of Southern culture. Those include the Columbus Museum, Westville Historic Handicrafts, Inc., Columbus State University, the Historic Chattahoochee Commission, the Historic Columbus Foundation, the Springer Opera House, and the Pasaquan Preservation Society.

Finally, I am grateful to the many people who allowed me to invade their front porches and their living rooms or enter their shops or tromp across their fields to make the pictures you see here. In my nearly three decades of picture-making, I have yet to be resolutely refused when I've asked permission to photograph someone. To my constant amazement, people are nearly always flattered when you ask, even if they are caught in an unflattering condition or position—in the dryer chair at a

local beauty shop, or hard at work in their soiled or tattered field clothing, or in the midst of butchering a fattened hog on a cold winter's day. Thanks to Lucius Robinson, Mr. and Mrs. Raymond Hill, Albert Macon, Hugh Overby, Butch Anthony, Cliff Davis, Buddy Snipes, Ray Parker, Joe Berry, Addie George, St. EOM, D. X. Gordy, McKinley James, Robert Thomas, Doug Booth, John Byrd, Patterson Moses, Wimbrick Cook, Henry Parker, John Henry Toney, and the many, many other residents of the lower Chattahoochee Valley region, both named and anonymous, who kept still for a moment or two on my behalf.

Preface

The photographs that are illustrated here in this book were made over a period of nearly twenty-five years, beginning about 1975. As I traveled around the Lower Chattahoochee River Valley during those years in my various capacities as a museum curator, a folklorist, a historic preservationist, and as a tourist, I always carried along my 35mm Nikon, mindfully ready to capture images that were distinctively Chattahoochee Valley. Later, when selecting the pictures that create the basis for this book, I was able to choose from a collection of more than twenty-five hundred 35mm transparencies and negatives, the majority of which have never before been printed.

The images that were finally chosen for inclusion here were selected for several reasons. First, I wanted each one to illustrate, in one way or another, a particular aspect of the folklife and the distinctive traditional culture that exists here in the Lower Chattahoochee Valley region. Secondly, I looked for images whose content, when carefully examined, could hardly be from any other place except the lower Chattahoochee Valley. That's my simple aim here—to illustrate little parts of this very distinctive and often peculiar region of the American South. It's the region where I was born, where I grew up, and where I live. I hope you will enjoy looking at it as much as I do.

—Fred C. Fussell

Foreword

The simple premise that guided the publication of this book was to provide an overview of the nature and importance of the folk traditions of the lower Chattahoochee Valley region of Alabama and Georgia. However, nothing is ever as simple as it sounds. This book is no exception. The folklife and cultural traditions of this eighteen county bi-state region is a complicated and often overlooked subject.

At the heart of this publication are the people who have perpetuated the songs, the stories, the arts, the craft—in short, the unique stuff of tradition—all based on information that has been handed down to them from their forebears. Unique folk traditions are what help to define a region's special character, and which sets it apart from any other area in the country. Without a doubt the lower Chattahoochee Valley is a very special and memorable place.

In his 1992 keynote address at the Historic Chattahoochee Commission's annual meeting, Billy Winn, the editorial page editor of the Columbus (Georgia) Ledger-Enquirer newspapers, addressed the subject of an area's special character when he noted that ". . . any significant culture stems from place, and more specifically from what the Mississippi writer Eudora Welty calls a *sense of place*. Like most people, I find myself drawn to locales that exude a strong sense of place, sometimes without knowing exactly why, but never just because of the scenery or the natural resources of such places."

Winn asked his audience to think about why cities like Charleston, Savannah, or New Orleans have such a strong sense of place. His answer was ". . . because the inhabitants of all these places believe themselves to be the inheritors and perpetrators of a significant culture which sustained their parents and grandparents, and will, with any luck, sustain their children and grandchildren as well. They not only know who they are, they know who their neighbors are, and who their own and their neighbors' ancestors were. They have a sense of their history, fostered by family and community tradition, and bolstered by the written word; for it is a characteristic of all people who believe them-selves to be a part of a significant culture that they make a concerted effort to document that culture and record and preserve their history, including their historic buildings and homes."

Visitors to the lower Chattahoochee Valley can feel and see this sense of place in communities like LaGrange, Valley, Hamilton, Opelika, Columbus, Pittsview, Cusseta, Eufaula, Lumpkin, Clayton, Georgetown, Abbeville, Fort Gaines, Columbia, Blakely, Headland, Donalsonville, Dothan, and Bainbridge—to name just a few.

Fred Fussell, Historic Chattahoochee Commission folklorist, has pulled together over twenty-five years worth of photographs, research, and experience to document the nature and importance of the folk traditions within this region. The result is this book: "*A Chattahoochee Album: Images of Traditional People and Folksy Places Around the Lower Chattahoochee River Valley of Alabama and Georgia.*"

Masterfully crafted by the sensitive hand and eye of Mr. Fussell, this small volume is sure to captivate the reader's attention as it explores the ever-changing folk traditions of the lower Chattahoochee River valley. This region's sense of place will be reinforced as well in the minds of area residents, who will recognize many of the people and places mentioned in this book. Those not fortunate enough to live in the Chattahoochee Valley will come to know this region's special character through Mr. Fussell's words and images.

Douglas Clare Purcell

Executive Director,
Historic Chattahoochee Commission

A
Chattahoochee
Album

Introduction

The Chattahoochee River begins its flow to the sea as a trickling little stream near the summit of Brasstown Bald, the highest peak in the hill country of north Georgia. It completes its course as a mighty Southern river where it meets the salty waters of the Gulf of Mexico at Apalachicola, Florida. The Lower Chattahoochee River Valley region, which is the focus of this book, is marked at its northern end by the point at which the Chattahoochee River, as it flows through the Georgia Piedmont, first touches Alabama. The southern end of the region is designated by the point where it connects with the Flint River at the Florida border. There the two joined rivers become the Apalachicola and flow on southward to the Gulf. East to west the Chattahoochee River's sphere of influence is defined by its watershed—with its thousands of tributaries—the creeks, streams, brooks, and branches which feed it. So defined, the Lower Chattahoochee River Valley region is, in essence, the geographical center of the Deep South. There are a total of eighteen counties that lie within the nucleus of the Lower Chattahoochee River Valley region—seven in Alabama, eleven in Georgia. The Chattahoochee region begins, in the north, at Troup County in Georgia and Chambers County in Alabama and then runs southward through Lee, Russell, Barbour, Henry, and Dale Counties in Alabama and through Harris, Muscogee, Chattahoochee, Stewart, Quitman, Randolph, Clay, Early, and Decatur Counties in Georgia to end up at Houston County in Alabama and Seminole County in Georgia, both of which border the Florida state line.

The region is also defined by its distinctive and diverse traditional culture, a culture that has been a long time in the making. The historical and social identity of the lower Chattahoochee River Valley began to take shape nearly four centuries ago when some of the earliest Europeans to arrive in continental North America encountered the indigenous Indians, who were already long-time occupants of the region. It is believed that Native American people of one kind or another had lived in and around the lower Chattahoochee River Valley for at least ten thousand years before the intruding Spaniards came here in the late Seventeenth Century. The very first European settlement in the Chattahoochee Valley was established in 1689 by Spanish monks who, accompanied by a garrison of

soldiers assigned to assist them, built the mission and fort of Apalachicola on the west bank of the Chattahoochee River. This site, located in Russell County, Alabama, lies about fifteen miles south of the present-day city of Columbus, Georgia, and is approximately 150 miles inland from the Gulf of Mexico and the Florida coastline.

As early as 1714, traders from the old Southwest—French Louisiana — became engaged in trade with the Indians of the Lower Chattahoochee River Valley. In 1739, General James Edward Oglethorpe, a trustee of the British colony of Georgia, traveled to the Chattahoochee to meet with Indian leaders at the Muskogee capital of Coweta in order to secure a treaty—a treaty that would, among other things, grant him permission to establish the colonial capital of Savannah on Georgia's Atlantic coast.

With the establishment of permanent European settlements in the Southeast in the 18th century—the British on the Atlantic coast, the Spanish along the Florida peninsula , and the French along the Gulf Coast—there followed frequent inward migrations of non-native traders and settlers into the Chattahoochee Valley. They came here from the British Isles and from Europe, from New England and from Africa, from the Carolinas, Virginia and New England and, occasionally, from Asia. Finally, in 1825, with the signing of the infamous Treaty of Indian Springs between the United States and the Creek Nation, the way was opened for the forced final removal of the native people from the region. That done, settlers came here in droves to establish cotton plantations, textile mills, riverboat companies, and all the other retail, supply, and labor services that were needed for the development and support of trade, commerce, industry, and agriculture. From this blending of people there developed in the lower Chattahoochee River Valley a singular culture that has persisted to the present—diverse, robust, and tradition-bound.

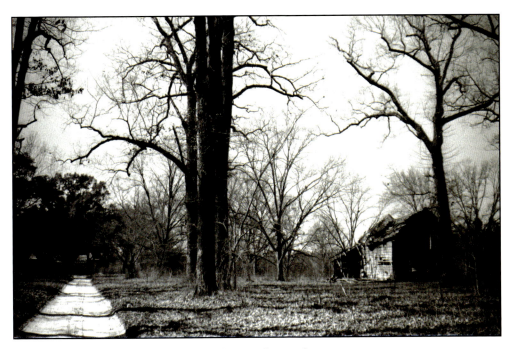

The front entry to the old Rood Plantation, Stewart County, Georgia

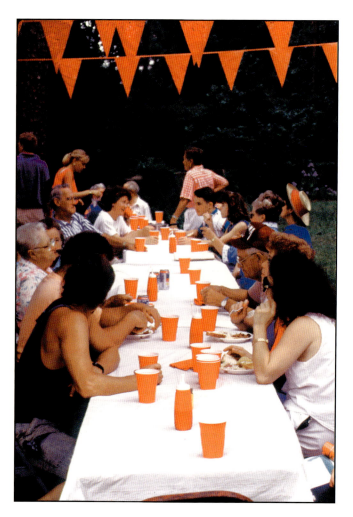

Guests enjoy cups of iced tea and plates of barbecue, potato salad, slaw, and Brunswick stew at the annual Dudley family Father's Day barbecue, Russell County, Alabama

Cooperation and Conflict

Even though the Chattahoochee River has served historically as the thread by which the region's cultural fabric is joined, it is also, and has always been, a source of conflict and tension between the neighboring states of Georgia and Alabama. The Georgia State line is located at the high water mark on the Alabama side of the river. Therefore Georgians, not Alabamians, have historically controlled the industrial and commercial development on the river's west bank, which is to say, in essence, that there has been none. Florida, Alabama, and Georgia are forever negotiating in an attempt to determine an equitable use of the river's water and the correct course of future development along the river's edge. At the core of the debate is the requirement of a stable water source for the city of Atlanta, which lies around sixty miles upstream from the point at which the river first encounters the Alabama state line. Urban water needs impact heavily upon the more rural-based communities of the lower Chattahoochee Valley region.

While the river and its water resources are often a source of contention between state development agencies and urban versus rural interests, the river serves equally as a force that binds the people of the region together. In the past, the river served as the main transportation route that linked regional communities one to another and then out to the larger world. By the middle of the Twentieth Century, however, the importance of the river as a transportation and commercial link had essentially faded away and had yielded to paved highways, railroads, and air freight.

People out on the river these days meet not as travellers, but as fun seekers. Bass boats hauling fishermen to their favorite haunts and jet skis hauling teenagers in never-ending circles have replaced the once prevalent steam-driven river boats hauling cotton and passengers to ports downstream. Today industry on the Georgia side of the river attracts workers from Alabama in large numbers, and Auburn University attracts a multitude of students from west Georgia into Alabama. Georgia lies in the Eastern time zone and Alabama in Central, yet several Alabama riverside towns observe Eastern as their standard timeset for the convenience of their citizens who commute into Georgia for work or shopping. In keeping with this practice, notices of the starting times of the many singing events in the

regional sacred harp tradition, for example, are usually announced in both Central and Eastern times in an effort to avoid confusion among the congregants, who may live in or travel from either of the time zones. High school athletic contests between Alabama and Georgia schools often begin on the half-hour so that the time discrepancy between the contesting schools is split and any resulting advantage or disadvantage is equally shared.

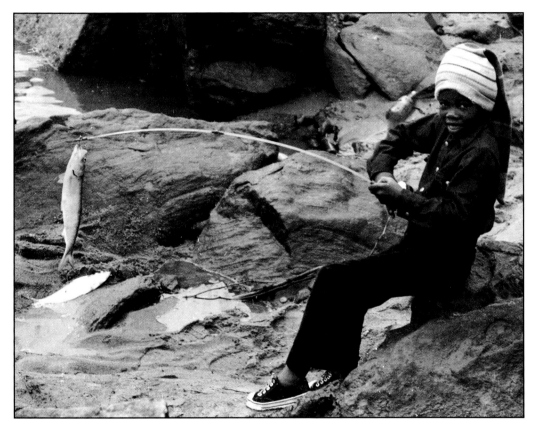

A young fisherman with his catch at the falls of the Chattahoochee in Columbus, Georgia

Randolph County, Georgia

Chattahoochee County, Georgia

A Cultural Corridor

The Chattahoochee Valley is a rich cultural corridor in which folk expression plays a vital role. Even though the region is generally underserved and economically poor, a limited amount of folk arts research and programming has been conducted here in the past. In the 1980s, the Columbus Museum produced a number of significant programs. These included a series of annual folklife festivals, a major exhibition of regional material folk culture, a folk arts film series, and other programming that employed regional traditional musicians, dancers, artisans, and other tradition holders.

The Columbus Museum sponsored the first significant folklife fieldwork to be conducted in the region, culminating in a five-year series of folk festivals which first publicly introduced such traditional artists as blues singer Precious Bryant, basketmaker Johnnie Ree Jackson, fiddlers Marion Jones, Carter Rushing, and Gene Jackson, and the Alabama blues and boogie duo of Albert Macon and Robert Thomas. Later, Columbus State University was instrumental in staging an ongoing series of programs that celebrated and interpreted contemporary Southeastern Indian traditional expression. Landmark Park, a living history center near Dothan, Alabama, has also contributed as an important venue for the demonstration and celebration of regional culture history and expression, as has the living history museum of Westville, at Lumpkin, Georgia.

The Alabama Center for Traditional Culture has conducted limited research into the region's traditions, focusing primarily on the documentation of African-American shape-note singing as it was exemplified in the Alabama Wiregrass by the late National Heritage Award recipient, Dewey P. Williams. In 1981, folklorist Henry Willett produced the LP and booklet "Wiregrass Notes: Black Sacred Harp Singing From Southeast Alabama." The Alabama Center for Traditional Culture, established in 1991, was created under Willett's direction to research, document, and present Alabama folklife.

The Historic Chattahoochee Commission, a bi-state agency that serves both Alabama and Georgia, provides a varied menu of cultural services within the region. A major component of the Commission's work is the development of programs and publications that focus on the distinctive nature of the region and its traditional culture. Since 1974, it has published more than twenty books relating

to the art, history, architecture, folklife, and archaeology of the Chattahoochee Valley region. The Historic Chattahoochee Commission effectively links the communities of the region and fosters an appreciation of regional culture unequaled by any other organization.

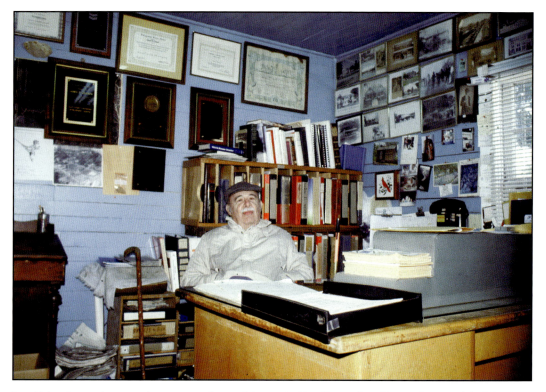

Local historian and community promoter Jimmy Coleman in his office in Fort Gaines, Georgia. Mr. Coleman has collected thousands of documents and objects that are of value in understanding the cultural history of Clay County and the surrounding area along the Chattahoochee River near Fort Gaines

The Chattahoochee Folklife Project

The Chattahoochee Folklife Project is an effort to build an ongoing and viable program of folklife activities in the region. With the support of earmarked project funding from the State of Georgia, the project has been able to acquire high quality sound and video recording equipment, computer systems, still photography equipment, and adequate supplies to enable an on-going program of documentation and presentation of folklife resources in the region. The Chattahoochee Folklife Project strives to identify and record the traditions of the region and to initiate planning for future programming.

A crucial aspect of its efforts is to produce folklife programming *within* the project region, thus assuring that the citizens of the project region are among the principal beneficiaries of the work, and that they are provided with ample opportunities to personally participate in project activities. The Chattahoochee Folklife Project has brought together the goals and resources of numerous organizations from both Georgia and Alabama to develop an unprecedented folklife program that focuses on the unique traditions of a region shared by two states. This undertaking serves to further enhance the cooperative program of work already initiated by the Historic Chattahoochee Commission. This publication is one result of that process.

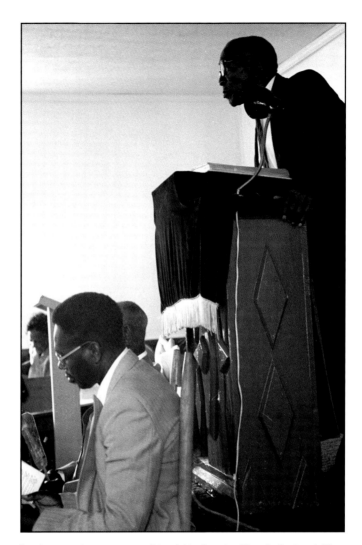

*Sunday morning sermon at Friendship Baptist Church, Society Hill,
Alabama. Religion and places of worship are among the strongest
of factors in the perpetuation of traditional Southern culture. From
the most humble to the very grandest, churches and their various
congregations are a major focal point in the preservation of
tradition in every Southern community.*

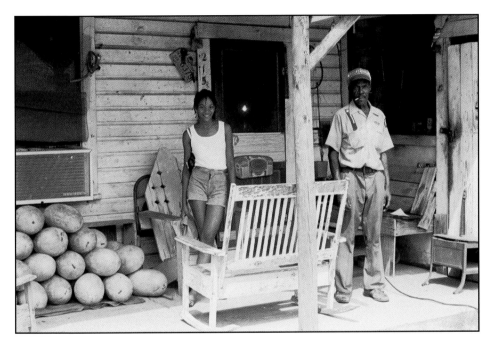

Watermelon vendors, Fort Gaines, Georgia

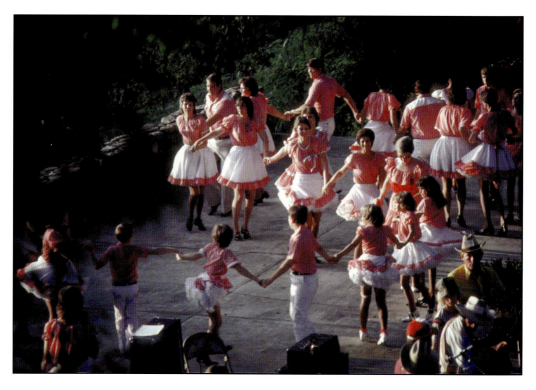

Cloggers at the 1994 Chattahoochee Folk Festival, Columbus, Georgia.

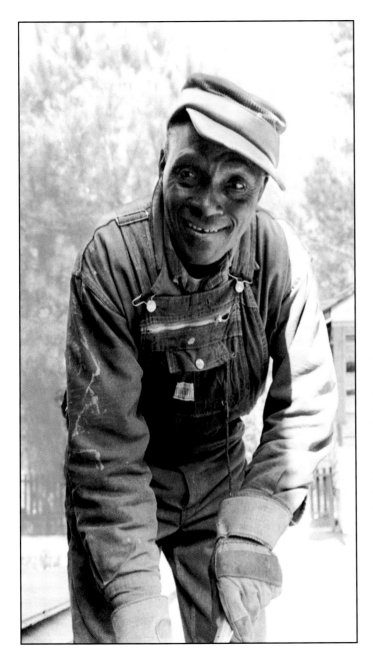

Cliff Davis lived in an old tenant house at the
Pleasant Valley community, near Lumpkin,
Georgia, in the early 1980s. It was there that he
was recorded by folklorist George Mitchell as he
sang his repertoire of field hollers and work songs.
Davis performed a very old style of unaccompa-
nied blues, work songs, and party songs, all
punctuated by his infectious and frequent
laughter, which was usually prompted by pretty
much anything he encountered or happened to
think about.

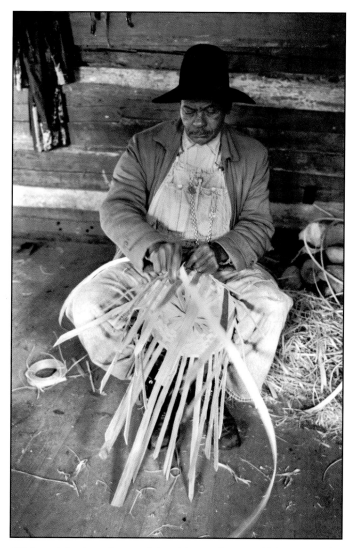

White oak basketry is one of the oldest and most widely practiced folk crafts in the Deep South. Pictured here is Gus Daniel of Stewart County, Georgia, who for many years demonstrated his skills on a daily basis at Westville. Daniel, like so many other basketers, learned the skill from his elders when he was a child on the farm.

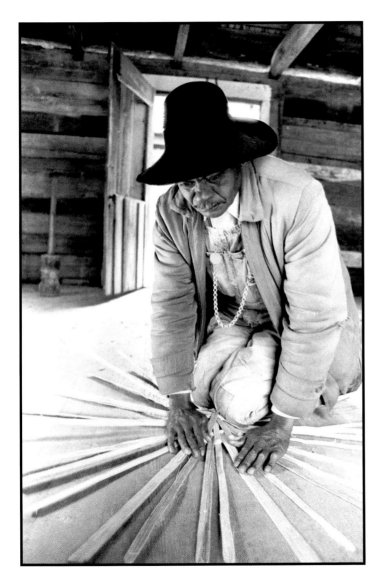

Gus Daniel at work laying out the white oak "ribs" for his basketry work. In traditional white oak basketry, the "runners" are the flexible horizontal strips of white oak that are woven in and out in an alternating pattern between the stiffer upright pieces, called "ribs." Coincidentally, a legendary snake found in the woods around Stewart County, Georgia, is also called a "white oak runner." The process of weaving a basket was referred to by Gus Daniel as "running it up." Among other specialized terms used by Daniel in his craft was the word "brickly," which describes "timber" that lacks the desired flexibility for good basket work and is, instead, easily broken as it is bent by the basketmakers hands and fingers.

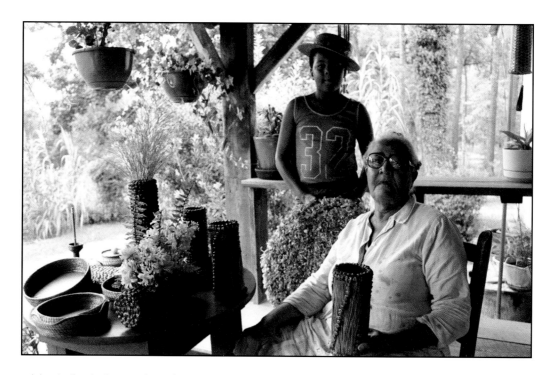

Johnnie Ree Jackson—shown here with her grandson, Elvis—lived her entire life of more than eighty years almost within sight of her birthplace near the Harris-Talbot county line, northeast of Columbus, Georgia. She was extraordinarily skilled in many traditional craftways, all of which she practiced with enthusiasm. She was a pine needle basket maker, a quilter, a cornshuck weaver, a broom maker, an avid gardener, and an expert herbalist. Mrs. Jackson even tried her hand, from time to time, at taxidermy, which she taught herself to do using methods she invented on her own. The rooms of her small white painted frame home were often decorated with woven baskets, hats, and trays, as well as with one or two of her "stuffed" gray squirrels, which she explained were prepared "just to be doin' something."

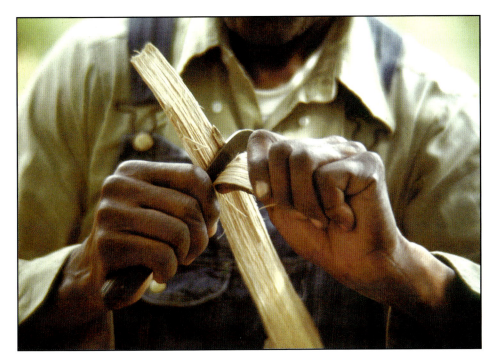

The hands of basketmaker Lucius Robinson, Stewart County, Georgia

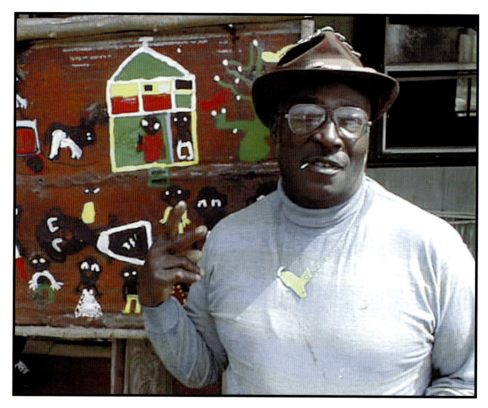

Folk artist James A. "Buddy" Snipes of Macon County, Alabama, standing in front of one of his many colorful creations.

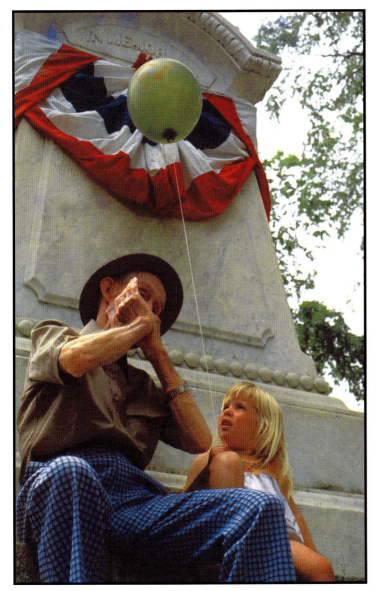

An old musician plays his harmonica for a young fan at the Salisbury Fair in Columbus, Georgia, about 1972.

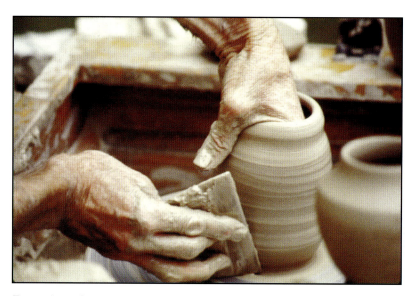

The making of stoneware pottery in the Chattahoochee region required both a thorough knowledge of chemistry and mechanics as well as a finely attuned sense of design. This knowledge was not learned in school, but was passed down in pottery making families from one generation to the next. Shown here are the hands of master potter D. X. Gordy of Meriwether County, Georgia. Gordy was a son, grandson, great-grandson, nephew, uncle, and brother of traditional potters in Georgia.

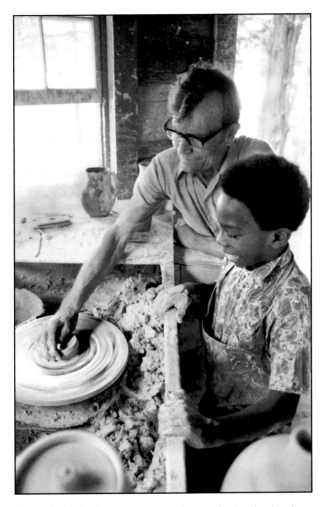

Potter D. X. Gordy instructs a student on basic wheelwork in the replicated 19th century pottery shop at Westville

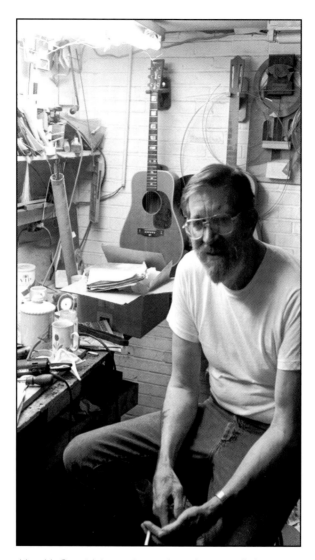

Mac McCormick is a guitar maker whose small shop is located in Columbus, Georgia. Mac's guitars, dobros, and other finely crafted handmade stringed instruments are highly prized by those who are fortunate enough to own and play them. Mac is also a highly skilled instrument repair technician.

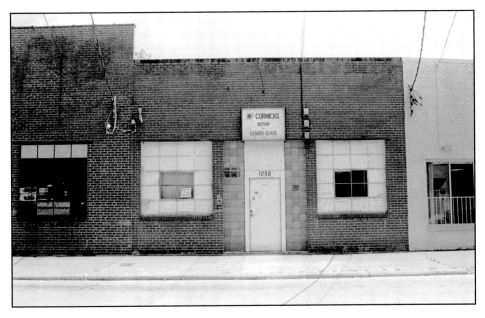

McCormick's Repair Shop on Midway Drive in Columbus, Georgia

Traditional Art and Anonymity

Historical precedents exist for much of the contemporary folk art and traditional craftwork found in the region today. A particularly important example of this is a large cypress wood sculpture titled *Minerva* that was produced in the 1850s by an unknown carver in Eufaula, Alabama. This bigger-than-life sized cypress sculpture was created to sit atop the Union Female Academy in 19th century Eufaula. Built in 1854, the Union Female College was designed and constructed by Eufaula architect George Whipple, who was a native of New Hampshire. When the College was finally dismantled in the mid-1910s, Minerva was lowered from her lofty perch and placed in the yard of a local residence. Later in the century she was entrusted to the Alabama Department of Archives and History in Montgomery, in whose collection she remains today.

In the past, such works as *Minerva* were often characterized as naive, primitive, or even inept attempts by self-taught or untrained artisans to imitate the work of classically trained artists. But as more and more examples of such work have been revealed, the realization has come that certain regionally identifiable styles and usages are at play, and that they demonstrate an artistic sophistication that was formerly not clearly understood or entirely acknowledged. Many contemporary traditional forms are derived, directly or indirectly, from such historical antecedents.

Created by another unidentified artist, the oil portrait titled *Mrs. Loverd Bryan and Her Firstborn*, a part of the collection at Westville, depicts a young Georgia mother and her infant child as they must have appeared on the Georgia frontier in the 1830s. Is this the work of a wandering itinerant who wandered across Georgia peddling his portraiture skills, or did Mrs. Bryan travel to Charleston, or perhaps to Baltimore, to have her likeness recorded? The answer is unknown, and may never come to light. Dozens of such portraits of early Southern town and frontier residents have survived; and many of them are from the hands of such unknown artists.

To this day, anonymity remains a characteristic for many traditional artists. Many of the makers of art and craftwork in the Chattahoochee Valley region have never intentionally sought to become

publicly known, at least not beyond their own local communities, and many have never deemed that there was any good reason why they should ever seek such recognition.

Some contemporary pine needle and split wood basketmaking traditions in the Chattahoochee Valley, perhaps by coincidence, reflect those of the native tribal people of the region. Traditional pottery styles in the region are almost certainly descended from those that were introduced into the region from England and western Europe via Virginia and the Carolinas in the 18th and 19th centuries. Carved wooden walking sticks and humorously rendered carved human faces are reminiscent of those that were produced by early immigrants from West Africa. These, and other less tangible forms, including music, storytelling, and traditional dance, are all evidence of the mostly anonymous origins of the indigenous traditional expression that flourishes in the Chattahoochee River Valley today.

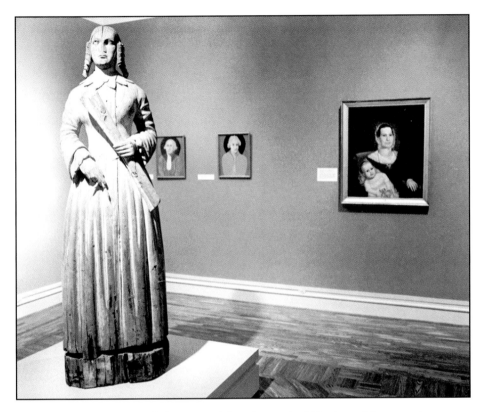

The carved cypress statue of Minerva and the oil portrait of Mrs. Loverd Bryan as they appeared on exhibit at the Columbus Museum, Columbus, Georgia, in 1996.

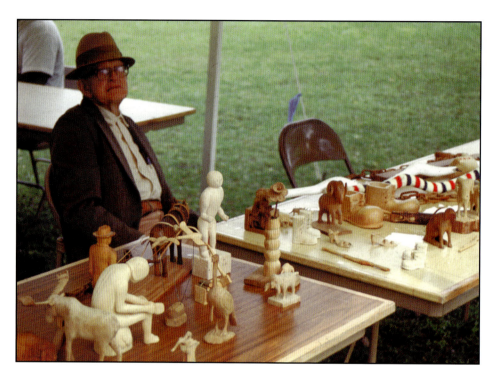

Traditional wood carver H.A. Brown with his work at the Chattahoochee Folk Festival, Columbus. Mr. Brown lived in LaGrange, Georgia.

Fiddle maker Carleton Woodson of LaGrange, Georgia, stands proudly at his front door with one of approximately thirty fiddles he has made since his retirement from his longtime job as a bookkeeper for the Callaway Mills in LaGrange.

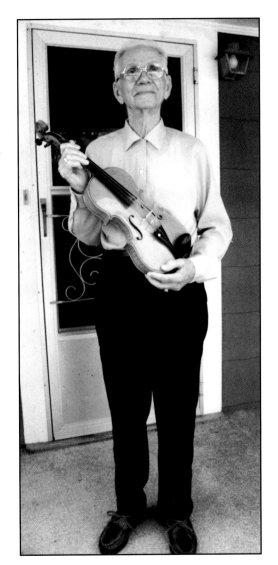

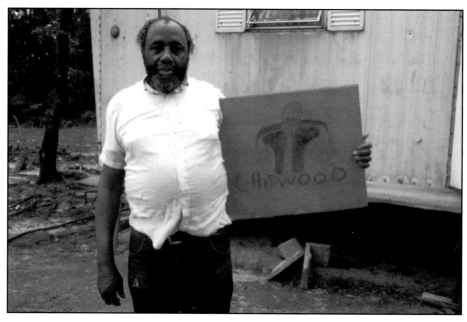

Artist John Henry Toney holding his pencil on cardboard portrait of Columbus Ledger-Enquirer columnist Tim Chitwood. Chitwood is a native of Seale, Alabama, where John Henry Toney lives and works.

Gourd tree, Clay County, Georgia. An uninformed visitor to the Chattahoochee Valley might assume that the dozens of white painted gourds seen suspended from wires and poles throughout the rural areas of the region are merely another form of strange yard decoration, of which such great variety abounds here. In fact, the custom of building the so-called "gourd trees" has the very practical effect of attracting flocks of insect-eating birds—Purple Martins—which have the legendary reputation for eating their weight in gnats and mosquitoes every day. Using gourd birdhouses to attract Purple Martins is a tradition that dates back in the region possibly as far as recorded history, and maybe even to prehistoric times. Thousands of gourds are grown by Valley residents every summer and suspended by the dozens the following spring to crossbars nailed near the tops of tall poles. Then watchful eyes keep a lookout for the first Purple Martin "scouts" to appear, hoping that the helpful birds will colonize and provide much needed relief from the ever-present swarms of mosquitoes and other pesky insects that inhabit the region each summer.

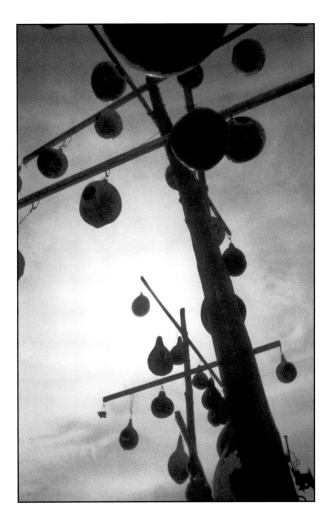

Eccentricity: A Southern Tradition

The American South, including the lower Chattahoochee River Valley, is a region well known for its colorful folkways and intriguing people. Every small town, every community, virtually every neighborhood in the South has had, and probably now has, local characters who are known for their eccentricities. Among them are certain people who, for varying reasons, produce highly individualistic artistic creations—extraordinary visions that lie beyond the commonly accepted bounds of artistic expression. Some of them, Marion County, Georgia's St. EOM for example, have based their creative efforts on a singular and powerfully emotional or religious experience. Others, including Jack Byrd of Lumpkin, have built whimsical whirligigs or other outlandish contraptions "just for the fun of it" or simply to pass the time. There are still others, including Sylvester Toney, Jr., of Cuthbert, who have chosen to express themselves for reasons that are not so easily understood, even to themselves. But each one, without exception, is driven far beyond the ordinary to follow a demanding urge to create and to be creative.

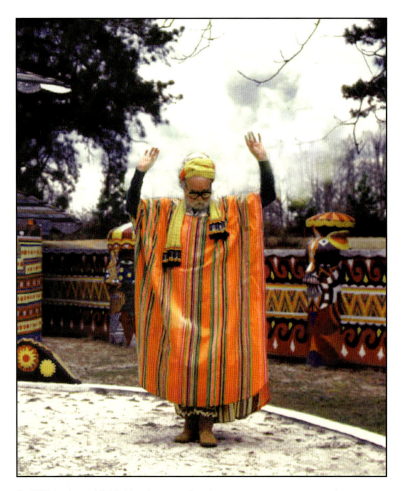

St. EOM, about 1969. Nearly every Southern town, every community, every neighborhood has its "character" who, for one reason or another, is "just different" from most folks. He or she is sometimes the "town drunk," or the high school "genius" who later "went off the deep end," or is simply the person who "walks to the beat of a different drummer." Whatever the case, this type of personality is as solid a part of traditional Southern culture as grits. St. EOM (Eddie Owens Martin) of Marion County, Georgia, was the king of them all. He spent over thirty years creating a four-acre visionary world of the future which he called "Pasaquan—where the past, present, future, and everything else all come together."

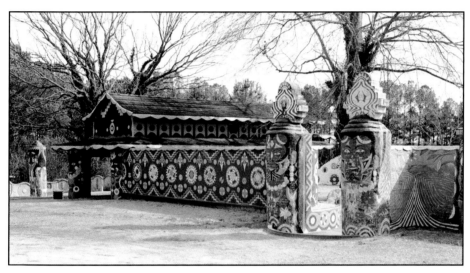

The front entry, St. EOM's Pasaquan, Marion County, Georgia

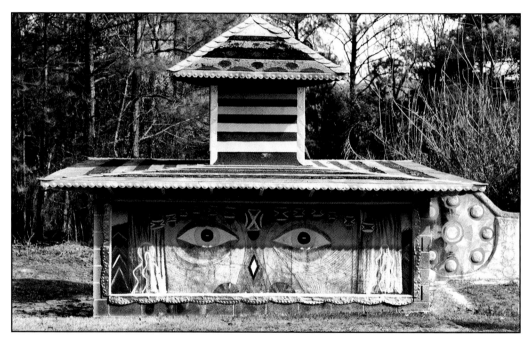

A decorated building at St. EOM's Pasaquan

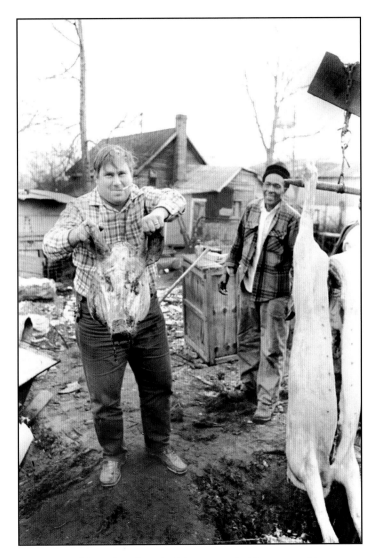

Ray Parker of Lumpkin, Georgia, jokes around with a severed hogs head as owner Percy Moses looks on.

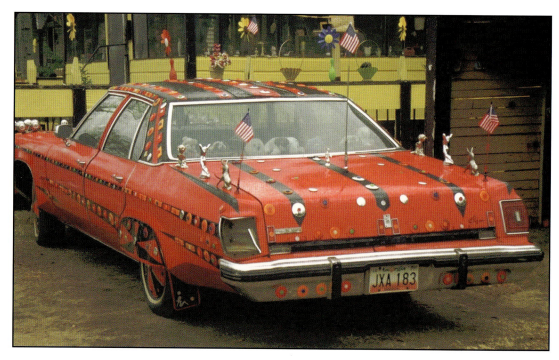

Extraordinary individual expression is not just tolerated in traditional Southern communities, but occasionally it is actually encouraged, even if only for the entertainment value that such exhibitionism offers. This image is of the eccentrically decorated automobile created by Sylvester Toney, Jr., of Cuthbert, Georgia.

Eccentric artist B. A. "Butch" Anthony, Possum Trot, Alabama

Hugh Overby, shown here at the Merritt Farm House at Westville, was one of the great rural characters of the Chattahoochee Valley region. Overby served as mayor of Richland, Georgia, for many years and also spent several terms in the Georgia state legislature. Mr. Overby was a graduate of Georgia Tech, where he played football in the early 1920s. He spent a good part of his last years as a daily volunteer at Westville, supervising the restoration of several of the buildings that are on exhibit there today, including the farm house and the cotton gin. Overby possessed a vast knowledge of traditional lore, particularly that which related to farming and to farmstead practices.

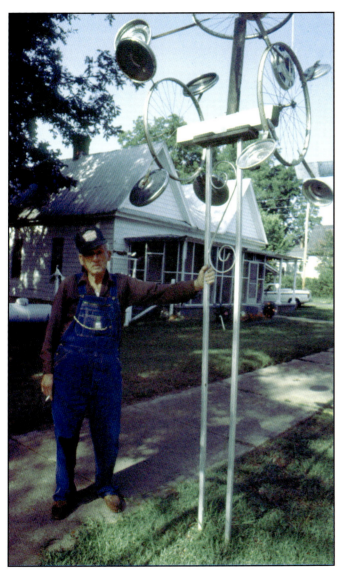

Making whirligigs and other whirring and whirling yard toys is an extremely popular traditional form of yard decoration in the Chattahoochee region. Shown here, standing beside several of his recent creations, is whirligig maker Jack Byrd of Lumpkin, Georgia. Mr. Byrd stated that his original intent was simply to entertain the children who happened to pass by. "But as it turns out," he said, "it's the grownups who seem to like 'em best—specially them from Atlanta."

A decorated house and yard, Russell County, Alabama

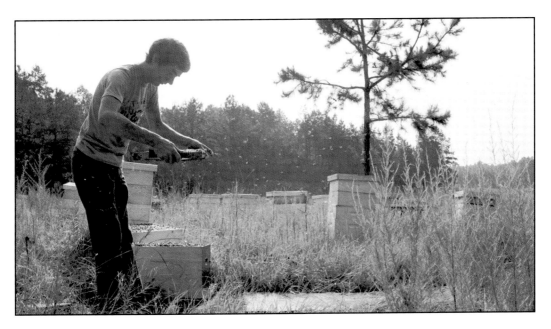

Wimbrick Cook examines a frame from one of his many bee boxes, or hives, at his farm near Buena Vista, Georgia.

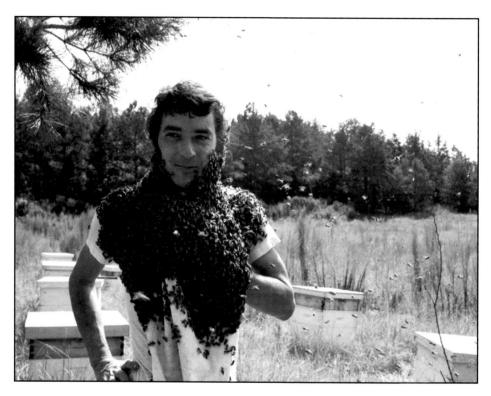

Wimbrick Cook manipulated a hive of living bees from his Marion County, Georgia, bee yard into the shape of a beard by taping the caged queen bee to his neck just below his chin. Within ten minutes, the entire hive had gathered on Cook's face and chest, as you see them here. Mr. Cook demonstrated bee keeping and honey preparation at the Chattahoochee Folk Festival in 1983.

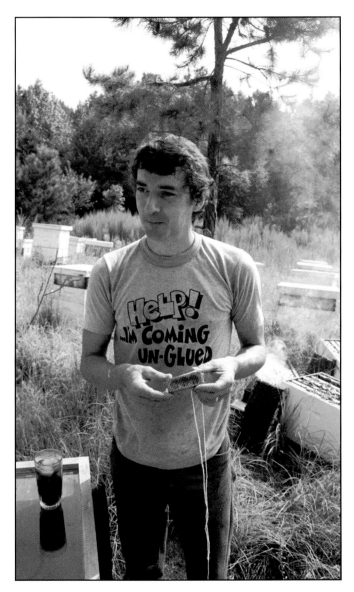

Wimbrick Cook holds a small wood and wire cage in which queen bees are transported from one location to another.

Made by Hand and Handed on Down

The making of handcrafts that are based upon traditional forms and methods of fabrication remains a vigorous activity among the people of the Chattahoochee Valley. There are dozens of Valley residents who work wood, make baskets, build musical instruments, fashion bird houses from home grown gourds, assemble and sew quilts, knit, tat and crochet, work metal, or employ any of a dozen other methods, using a variety of materials, to produce handwrought objects. The only other means of traditional cultural expression in the region which may exceed the popularity of traditional crafts making are music making and home cooking. However, foremost among the popular traditional craftways in the region are two media—woodworking and quiltmaking. One or the other of these two divergent craftways is practiced by many, many scores of people in the Chattahoochee Valley.

Quilting and other forms of needlecraft—knitting, embroidering, crocheting, tatting, lacemaking,—are all practiced here. Within the quiltmaking tradition, there are two major veins of expression which have developed during the past 150 years or longer—Euro-American and African American. While Euro-American quilts lean toward precisely and carefully planned and executed geometric patterns and color themes, African American quilts are typically more individualistic in their form and execution. However, as with virtually every other aspect of traditional expression in the region, there are very few clearly delineated boundaries between the two groups, and there is a high degree of cross-over in materials, patterns, and techniques among Chattahoochee Valley quilters, regardless of ethnicity.

The availability of native woods in abundant variety must surely account, in great part, for the extreme popularity of woodworking in the Chattahoochee Valley region. In addition to the longtime uses of native pine, oak, poplar, beech, maple, and cypress wood for making houses and household furnishings, Valley craftspeople also utilize native woods in the production of a great many other items. Skilled hands chip, chop, saw, split, whittle, hew, hack, carve, paint, shellac, and varnish wood in a seemingly endless variety of ways to create baskets, chairs, porch swings, hat and coat racks, boxes, bowls, chests, cabinets, spoons, and walking sticks. More often than not, the work that is produced goes beyond that of being simply utilitarian. It is formed into beautifully crafted and deftly fashioned works of art, made as much to please the eye and mind as to serve a particular function.

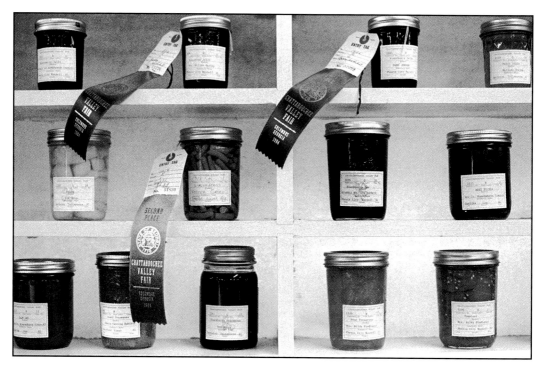

A selection of homemade canned foods on display at the Chattahoochee Exposition, the annual regional agricultural fair and carnival in Columbus. Although not as commonplace and widespread as several decades ago, the preparation and preservation of home grown foods is still a popular regional activity, particularly in the rural areas. Scores of families join together every year in the work of canning fruits and vegetables, making jams, jellies and preserves, and curing meat and smoking hams.

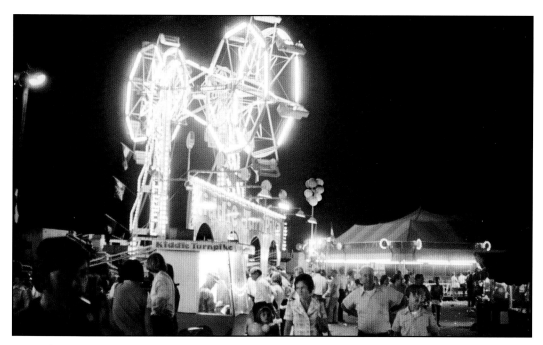

"Gooding's Million Dollar Midway," at night, The Chattahoochee Valley Exposition, Columbus

Games of skill and chance are a traditional feature of the Chattahoochee Valley Fair, Columbus, Georgia.

Potter Ned Berry of Harris County, Georgia, holding a "face jug" titled "Race for the White House." Berry made the piece as a parody of the 1996 Presidential electoral process.

D. X. Gordy, about 1974. Pottery making in the Chattahoochee Valley has its local roots in the early 19th century. For many decades, stoneware jugs, churns, bottles, and bowls produced by regional potters were essential components of local households. The prohibition period of the 1920s and early 1930s was an especially busy time for regional jug factories, when the production of contraband "moonshine" whiskey was a major activity in the region. The end of prohibition and the later advent of inexpensive glass, paper, and plastic containers in which store-bought goods were sold and stored, brought an end to the demand for utilitarian containers made from local clay. Many potters were forced to abandon their shops and to pursue other trades. As early as the 1940s, however, a few shops, including that of the Gordy family in Meriwether County, turned to producing highly decorative wares, often referred to as "art pottery."

D. X. Gordy, along with his father, W. T. B. Gordy, and several other relatives, focused their efforts on producing beautifully

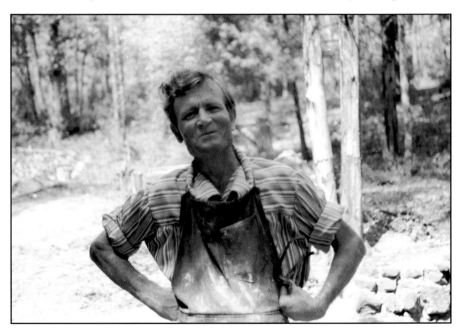

glazed and highly finished stoneware vases, pitchers, tea sets, and occasional figurative pieces. Such families prided themselves on their craft. D.X. Gordy was often heard to say, "You might say I was raised in pottery." Some members of pottery-making families even created stoneware grave markers in the form of large urns to commemorate the final resting places of their deceased relatives, as can be seen in the photograph (on page 116) of the grave marker of a Louise Brown. The base of another stoneware marker, shown on page 117, clearly displays the inscribed mark of its maker— "W.T.B. Gordy, Alvaton, Georgia." Unfortunately, many such pottery markers have been stolen from cemeteries by unscrupulous collectors or broken by vandals, so the location of this grave site shown here will go unnamed in order to protect it.

Today, there are only a few traditional potters who remain active in the region. Notable among them is Stephen Hawks, who operates the replicated pottery shop at the living history village of Westville, and Ned Berry, whose grandfather was a traditional potter in Girard, Alabama.

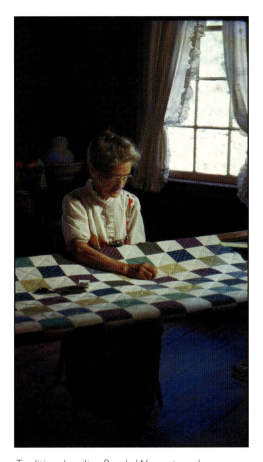

Traditional quilter Pearle Ware at work on a simple patchwork quilt at her frame in the Grimes-Feagin House, Westville. Mrs. Ware was an energetic craftsperson whose repertoire of quilt patterns numbered in the hundreds. She was also a locally famous marathon talker.

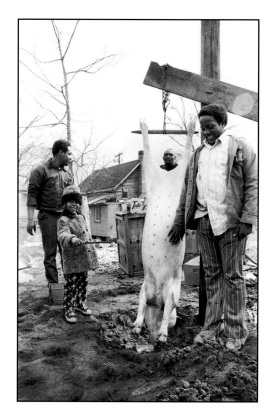

Hog killing day at Percy Moses', Lumpkin, Georgia

Cleaning chitterlings or "chitlins" on hog killing day. There are two principal methods: "thumb-stripping" and "stump-slinging."

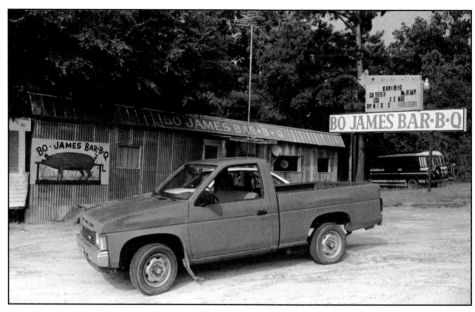

Bo James BAR-B-Q restaurant, a few miles west of Columbia, Alabama.

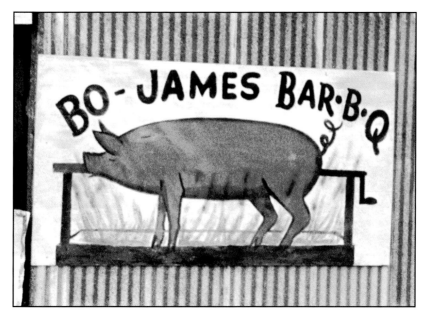

A closeup view of the handpainted sign of a roasting pig on a spit, Bo James BAR-B-Q, Columbia, Alabama. Homemade trade signs such as this one in Southeast Alabama are a part of a longstanding tradition that dates back to Colonial times. A careful look around the country roads and town streets of the Chattahoochee Valley will reveal scores of such signs made by local merchants and farmers.

What We Eat

"*Y'all don't like grits?*" That's a question that native Southerners just love to ask outsiders. Most of the time this question is reserved for anyone perceived to be a *Yankee*, and Yankees can be anyone not considered by the questioner to be a Southerner, as he or she defines it. Californians, Kansans, Ohioans, New Yorkers, Nebraskans, Hawaiians, West Virginians, or Canadians are all equally eligible to be considered as Yankees. So are almost all non-native Floridians. But grits alone do not define deep Southern cuisine or culture. The real defining factor, of course, is pit barbecue.

To be considered as real and authentic, Southern barbecue, at least in the lower Chattahoochee Valley, has to be pit cooked and it must be pork—not beef, not lamb, not chicken. Barbecued chicken is admittedly very popular here. So are barbecued pork ribs. But only fleshy pork cuts such as Boston Butts can be called *barbecue* with no definers added. If a person says "I sure would like a barbecue sandwich," then it's understood by all around that they mean pit cooked pork and nothing else—pork that has been *slowly* roasted over an earthen pit and gently bathed in the warm thick smoke of smoldering, sizzling coals of green hickory or oak wood. Some swear by using nothing but hickory to fuel the fire, others by blackjack oak, and a few by pecan, but all agree on pork. They may calmly discuss the attributes of the smoke that is produced by each kind of wood, using such terms as sweetness, flavor, fragrance, and coolness, but the meat of choice never varies. It's pork.

Randolph County, Georgia

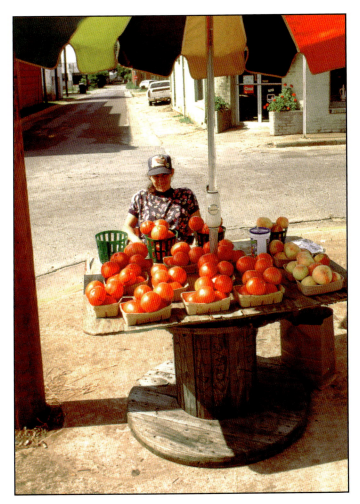

A sidewalk fruit and vegetable vendor, Cuthbert, Georgia. Once the voices of street peddlers loudly singing the praises of their merchandise or the sound of a truck horn announcing the arrival of a rolling store or the "ice man" were commonplace, everyday noises in the Chattahoochee Valley. Now the occasional roadside vendor of boiled peanuts, fresh produce, or "Kountry Krafts," and the numerous yard sales that are scattered here and there are about the only surviving remnants of a once vigorous local merchandising industry. The advent of super stores, chain food markets, and fast food restaurants has forever changed the face of traditional commerce in the South.

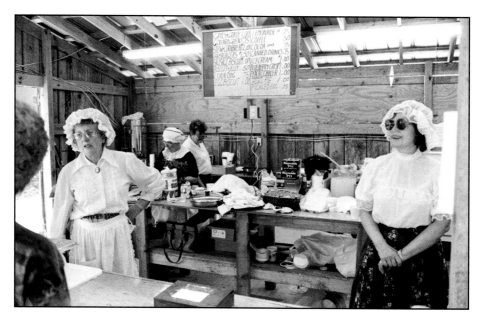

Volunteers at the "Food Shack" at the annual "Syrup Soppin'," in Loachapoka, Alabama. The event is sponsored by several Lee County agencies as a fund raiser for historic preservation efforts there.

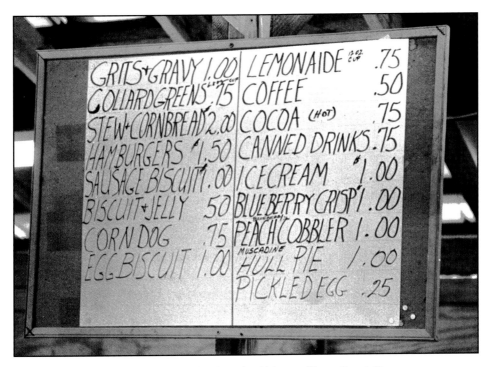

A closeup of the menu board at the Loachapoka, Alabama, "Syrup Soppin'."

Cuthbert, Georgia

Mr. Walter Brown, Stewart County, Georgia. Mr. Brown was an old-time farmer who was also an avid square dance caller. He stated that he spent many, many hours practicing his repertoire of dance calls while staring at the hind end of a mule as he plowed. According to Mr. Brown, his calling helped to pass the time away and it also entertained the mule.

How We Talk

Depending on such nebulous things as family customs and tendencies, individual personalities and circumstances, community tolerances and the availability of leisure time, the practices of exaggerated talk, unbridled gossip, yarn spinning, and reciting tall tales and jokes are among the most highly popular pastimes among the traditional people of the Chattahoochee Valley. Throughout the region on any given day, especially on Saturdays and rainy days, there are scores of informal gatherings at countless country stores, beauty and barber shops, small town cafes, pool halls, service stations, front porches, and backyards, to talk. And talk—pure talk—is the order of the day.

There really is a sort of order to all this talk. Following the obligatory exchanges of *How's it goin'? How You? Can't complain, I guess. Me neither*, the weather is discussed and commented on at length. *Reckon it'll rain? Ain't it hot? Sure has been dry, hadn't it? Hot enough for you? We sure could use a shower...might cool things off.* After that the news of ailments and injuries suffered by neighbors and kinfolk far and wide are listed. *I heard Jim Junior Thornton stepped on a nail and it went clean through to the top of his shoe and they had to cut it off of 'im. It was special bad 'cause he was just finishing up cleaning out the chicken coop. That's what I heard.* Then on some more, on past the rising costs of groceries, automobiles, farm supplies and seed; on past who had company from out of town and where do they live now and *how long had she been away from home this time before she came back here to see her mama she ought to be ashamed but I know she has to put up with that sorry husband of hers and that can't be easy;* past how many catfish they picked up last weekend by the basketful *when Mister Charlie Grimes drained his pond 'cause he wants to restock it with just bream why I don't know I'd rather have catfish any day hadn't you;* and on past if the school board needs to spend any more money on computers or not *even if it is government grant money when they don't even have enough books to go around and all those children do anyhow is play those computer games and try to see what they can find on that internet and you know what I'm talking about...*and on and on.

Real formalized storytelling in the sense of there being a teller who tells to an audience and an audience that listens to a teller Appalachian style is a rare occurrence here. Stories here in the

Chattahoochee Valley, even the most often repeated and traditional ones, are almost always personalized in a way that not only suits the teller's style but also involves the teller as an eye witness to the event described. In other words, the teller of the story seldom repeats it in exactly the same way it was heard. Some viable connection to the teller, and often to the listeners, is usually added. Oh, sure, parents tell their young children the standard versions of the traditionally popular fairy tales—or read them to the children from books—but formulated stories that are passed down relatively unchanged from generation to generation are rare here.

Here's a regional story that had been told and heard a thousand times before in a thousand different places, but the basic tale is always told the same and it's always told for the absolute truth from the mouth of an eye witness. This style of tale and telling of tales almost always comes from male talkers talking to male listeners. This is the story of a prized hunting hound gone bad:

On yonder back there, there was a certain old man—let's call him Brother Lynch. Y'all probably all know his people cause they've all lived around here forever. Well, Brother Lynch was something past his prime in age, but he still loved to go coon hunting better than anything or anybody. And he had an old redbone hound that he gave the name of Red. It was a big ol' redbone that he had named Red, 'cause of its color. Old Red was a little past his prime, too, but Brother Lynch loved old Red better'n anything and couldn't see nothin' about him that was in the least wrong, neither comin' nor goin'.

Well, one time old man Brother Man Lynch and old Red were invited to go coon hunting on a cold night with a group of younger men, and they all had their own hounds, too. So right after supper they all loaded up and went on out to their favorite hunting place by a big peanut field in their pickup trucks, and they let the dogs out of the back to circle up and go find the trace of a coon.

While they were waiting, they all settled in on a little hilltop. They got up on a high place, you know, so they could hear the voices of the dogs real good while they trailed and treed. The men built up a little fire to help keep off the chill of the night air. They all sat around in a circle there by that fire, and they talked kinda quiet and told a few little jokes and I think I remember they passed around a little bottle of Bourbon for the benefit of them that wanted a taste. It was a pretty chilly night, too.

Directly the barking of the dogs picked up and the men got real quiet and listened real careful with their heads all tilted over to one side. Pretty soon they agreed all around that the dogs had struck the trail. All of a sudden, Brother Lynch stood up and took five or six steps real quick toward the sound of the barking dogs. He cupped his hand up to his ear like this and declared, "Boys, would y'all just listen to that now! Huh? That's my Ol' Red y'all all hear out there. Man, I can tell his voice anywhere! Could be a thousand dogs out there

and I can pick him up. Listen to him sing! Now, boys, that's the voice of authority y'all hear out there. He's sho' teaching those young dogs somethin' 'bout a coon, ain't he? Whoo-eee!"

About then a kind of a dry scratching sound was heard coming out from under a low bush that wadn't too far away from the fire. I was right there and saw this myself. One of the men turned around and aimed his flashlight right at that sound. And sure enough, there was something there. "Brother Lynch," he asked him, "Ain't that your Ol' Red laying over there by that bush scratching his fleas?"

Well, you guessed it. It was. It was old Red, true enough, just laying over there and scratching his ears like nobody's business, and him not even knowing that he just made a complete fool out of his master, Brother Lynch. And Brother Lynch never did live that one down, neither. We wouldn't let him! No sir, we never would let him! No!

Here everyone laughs and someone tells the teller "That's a good one, Bill!" and another one says "I sho' bet that got off with him," and so on, just as if they'd never before heard that story in their entire lives.

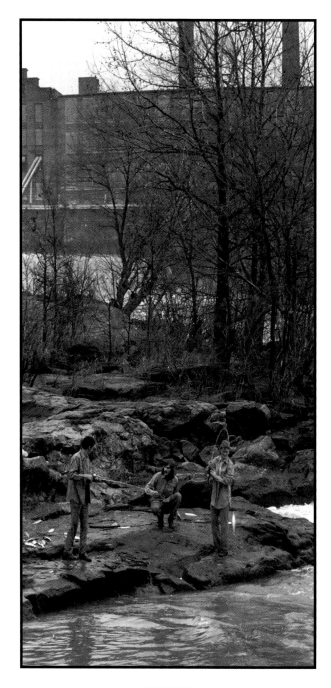

Fishing at the fall line of the river in springtime is an ancient ritual in the Chattahoochee Valley. Each year, as fish make their way upstream to spawn, the fishermen turn out in droves to have some fun.

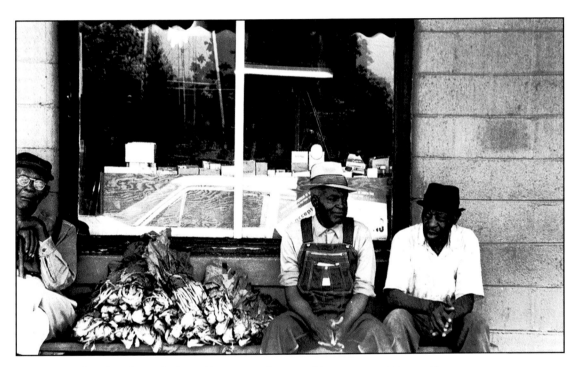
Men sit on a bench in front of a Lumpkin store to discuss politics, crops, and the weather.

Conversation at House's Gulf Station, Lumpkin

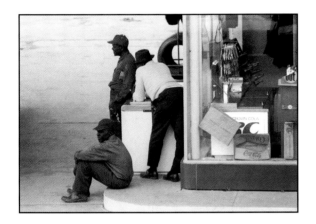

A slow afternoon in Lumpkin

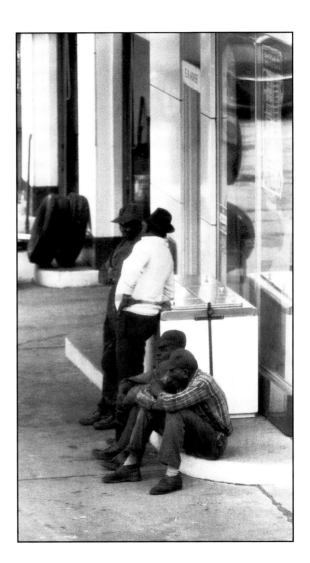

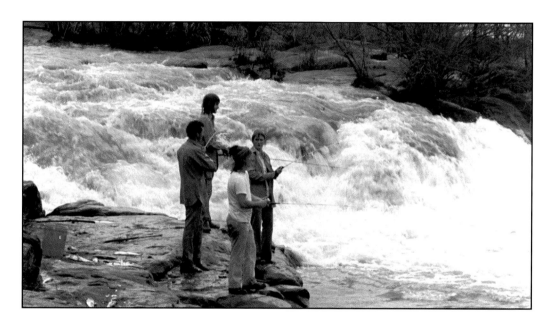

Fishing at the falls, Phenix City, Alabama . The traditions and customs of a region are passed along from one generation to the next, from one person to another. This is done not through formal instruction, but by word of mouth and by demonstration. The way we sound when we talk, the songs we sing at home or at church and the way we sing and play them, the foods we cook and eat and the ways we cook and eat them, the ways we hunt, fish, and keep our gardens, the games we play as children—these are all examples of the many traditions that each of us learns and, in turn, passes along to others.

Indians in the Chattahoochee Valley

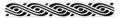

The Native American presence here in the lower Chattahoochee Valley, or what's left of it, is made mostly of imagination and memory. No formalized tribal groups or Indian organizations in the region are the direct cultural descendants of the native people who occupied this land before the "Trail of Tears" and *Indian removal* of the 19th century.

Recently, principally because the effects of the civil rights movement has allowed for such, Southerners both black and white are increasingly laying their claims to previously denied ancestral links, especially if those links happen to be Native American. Thousands of Southerners can now be seen proudly displaying their Indian-related ornaments. They drape dreamcatchers, furry prayer rings, and bundles of small feathers on rearview mirrors to sway gently from side to side as they travel along, their vehicle bumpers sporting such sticker slogans as "Custer had it coming," I brake for fry bread," or "Indian and proud of it."

Here in the Chattahoochee Valley, this trend seems to be fairly well regionalized and seems much more pronounced in the Alabama counties than in Georgia. Informal observation indicates that it is the Alabamians who more aggressively lay claim to a Native American descent. There are several formalized groups with members who live in eastern Alabama and who claim a shared tribal ancestry. The most visible of these are *The Cherokees of Southeast Alabama*, an organization headquartered in Columbia, Alabama, which lists its members as mostly from the western Chattahoochee region, from Valley to Ozark. The Cherokees of Southeast Alabama are one of seven such groups to have gained official recognition from the State of Alabama as Native American tribal groups.

Since nearly all, if not all, of the true vestiges of traditional Southeastern Indian ceremonialism have faded completely away among these individual Alabama families and communities, the claimants have found a more easily accessible means of renewing their rightful place as Indian descendants. They have turned to the contemporary pow-wow event, which allows everyone who attends an opportunity to participate in ritual and to demonstrate his or her connectiveness to the group and to Native American culture in general.

The Cherokees of Southeast Alabama host an annual pow-wow at which they and guests from other Alabama tribal groups join together for a day of ceremonial self-celebration and sociability. The non-Indian public is welcomed to the event and even encouraged to join in at certain times during the festivities. Some tribal members dress in pan-Indian regalia, some of which is very elaborately fabricated, while others sport t-shirts emblazoned with tribal or clan logos. A few even don replicated 19th century Southeastern Indian style tunics, beaded sashes, and plumed turbans as they dance and sing pow-wow style to the rhythmic beat of the drum.

The ceremonial drum, often referred to as "the heartbeat of the Indian people," is customarily and enthusiastically played at powwows, Northern style or Southern style, by a team of semi-professional singers and drummers who are almost always members of tribal groups from west of the Mississippi River, or from the Eastern Band of Cherokee Indians in North Carolina. There are also certain appointed, elected, and honorary officials—a master of ceremonies, a head man dancer, a head lady dancer, and so on—who preside over the day's events. In addition, there are various elected tribal and clan officials present. Everyone has a part to play and there is much behind the scenes discussion regarding proper protocol and order of events as the day goes along.

Nevertheless, the strongest indication of a native American influence on the Lower Chattahoochee River Valley region is simply the hundreds of place names and the many names of creeks, rivers, and streams that derive from native tongues and their variants—Yuchi, Hitchitee, Muscogee, Choctaw, Chickasaw, Cherokee, Seminole

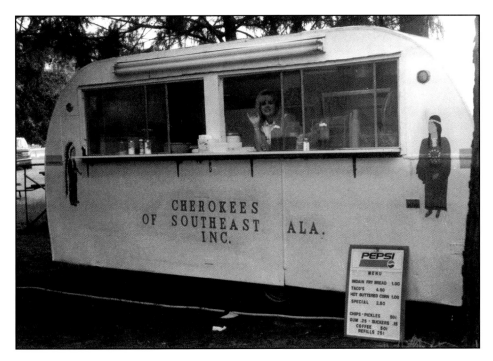

This decorated trailer is used by the Cherokees of Southeast Alabama at pow-wows as a vending station for both "Indian" and other foods. The menu features Indian fry bread, tacos, hot buttered corn, chips, pickles, gum, suckers, and coffee.

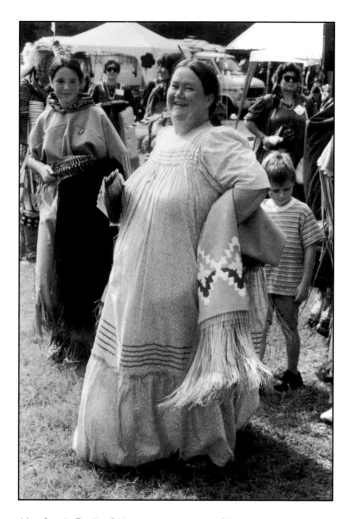

Mrs. Sandy Faulk of Montgomery is one of the principal organizers of the annual powwow that is sponsored by the Cherokees of Southeast Alabama. The festival is held each year at Osmussee Creek Park, Columbia, Alabama

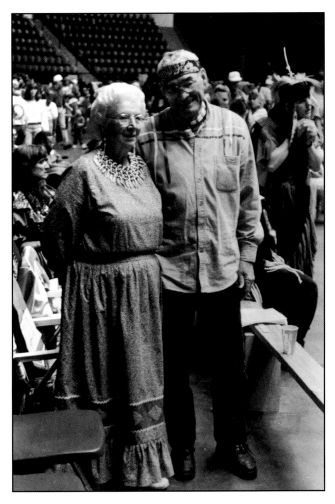

Pictured here at the Alabama State Powwow held annually at the Montgomery Coliseum are Mr. and Mrs. Raymond Hill of Valley, Alabama. The Hills are both members of the Cherokees of Southeast Alabama, in which Mr. Hill serves as chief of the Blue Holly clan.

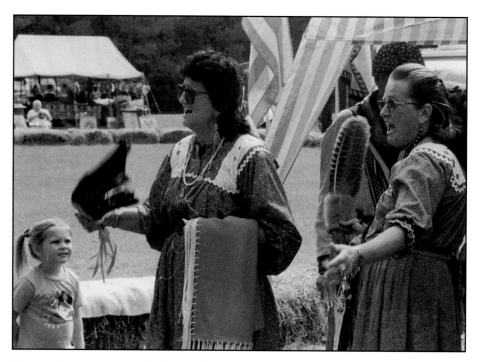

Dancers chant and sing to the beat of the drum as they dance powwow style at the annual gathering at Osmussee State Park, Columbia, Alabama

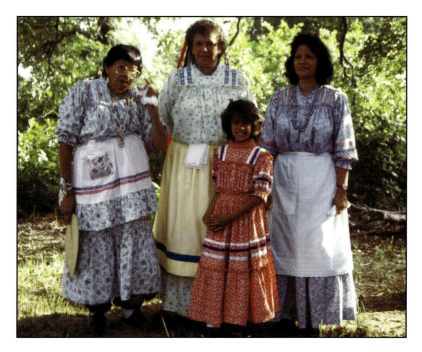

Three generations of Yuchi women wearing traditional dress are represented in this picture that was made at the site of the annual Yuchi Green Corn Ceremonial near Kelleyville, Oklahoma. They are, left to right, tribal matriarch Addie George; her daughter Ramona Sweeney; Ramona's granddaughter; and another of Addie George's daughters, Valerie George. The word Yuchi—spelled variously as Yuchi, Uchee, and Oochee, and pronounced variously as YOU-chee or oo-chee, depending on where or who you are, is the name of a Native American tribal group that inhabited the Chattahoochee Valley in the 18th and early 19th centuries.

Shown in these photographs is Mrs. Addie George, a native of Sapulpa, Oklahoma, and a matriarch of the contemporary Yuchi tribe. Mrs. George is pictured standing near the highway bridge which passes over Oochee Creek a mile or so north of Buena Vista, Georgia, and which is adjacent to the site of an important Yuchi settlement of the early 19th century. In the late 1950s, the Yuchis renewed their nearly forsaken contact with the lower Chattahoochee Valley at the invitation of Joseph B. Mahan, who was then curator of the Columbus Museum. Since then, representatives of the Yuchi people have visited the region many times.

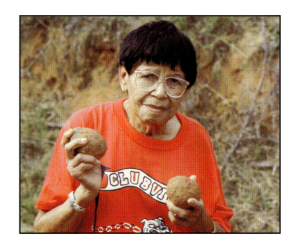

In the top photograph, Mrs. George holds two iron ore nodules. The hollow centers of these natural rocks often contain a powdery red or yellow pigment that is used ceremonially by the Yuchis. The use of these and other natural materials gathered from the Chattahoochee Valley in tribal rituals still practiced in Oklahoma has a special meaning for many traditional Yuchis, who enjoy both the real and implied significance of the resulting connection to their former beloved homeland.

Addie George has often served as an artist in residence in the Muscogee County Schools. She is a skilled craftsperson who fabricates traditional beadwork, baskets, fingerweaving, and a variety of handcrafted traditional religious paraphernalia.

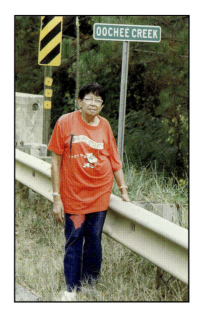

A Regional Distinctiveness

The lower Chattahoochee region is a relatively small area of the Southeastern United States, yet it has a certain distinctiveness of its own when it comes to the way people talk and to the names that we give to the things that we talk about. It is the variations in how we sound when we talk—and how we say what we say—that are the dead giveaways for our geographic origins, no matter where we come from. For instance, at various places around the United States, depending on where you are at the time, a soft drink could be called "a soda pop," or "a pop," or "a tonic," or any number of other local names. Here in the Chattahoochee Valley, it's usually a "drink" (pronounced *drank*) or (regardless of the actual brand name) a "Coke."

Until the mid-1950s and the advent of television, residents of the Valley were mostly inclined to refer to the midday meal as dinner—not lunch—and the evening meal was supper, not dinner. *Brunch* was an unknown word (and virtually an unheard of concept) then. Foreign language words and words borrowed from Native American languages have not fared well here either, at least in terms of pronunciation. The central word of our discourse—"Chattahoochee"—is usually declared as originating in the Muskogean language, and it is generally dispatched with meaning something like "painted rock." Fluent native Muskogean speakers, however, can't seem to make much, if any, sense of it at all. The same is true of many other Muskogean "sounding" words that are now employed as regional place names—*Weracoba*, *Kinchafoonee*, *Pataula*, and *Hodchodkee*, for starters. The English mispronunciation of such words through the decades, along with the various spellings and misspellings that have been applied over the years, have reduced many of the original names and words to indecipherable nonsense.

Much has been made regarding the dialectical differences between black and white speech patterns in the deep South, but such differences are subtle and are often much more closely tied to geographical and economic factors than to ethnicity. In certain parts of southeastern Alabama, some Caucasian people ride "on" their automobiles—not in them. The same folks may well place an "ey" ending on certain words that were never meant to have one: *tomatey* for tomato is the most fre-

quently heard example, along with piney for pine, as in "piney woods." Examples of widespread regional pronunciations of common words among African-Americans in the region are "axe" for ask, and the often-heard substitution of *cr* for *tr* as in "scrawberry" or "elecricity." On the other hand, African-Americans in the region will pronounce the word *aunt* as if they were tidewater Virginians rather than following the pronunciation of their white neighbors, who say it like "ant" or, if they're older, "ain't."

Many of the town names in the region commemorate famous people (Columbus, Lumpkin, Hamilton, Cuthbert, Bainbridge), others are taken from famous places (Brooklyn, Omaha, Geneva, Shiloh, Manchester, LaGrange, Texas), some are named for early settlers, military leaders, or pioneer families (Skipperville, Fort Mitchell, Fort Gaines, Hurtsboro, Pittsview, Shorterville), while many others are derived from Southeastern Indian words or phrases (Cusseta, Opelika, Eufaula, Colomokee, Upatoi, Muscogee, Hatchechubbee, Loachapoka), and still others are named for unusual geographical features or landmarks (Climax, Warm Springs, Bluffton, Springvale, Plains, Cottonton, West Point, County Line). A few even have literary or mythological origins (Auburn, Nankipoo, Dothan, Damascus, Phenix City).

Up River and Down Home

Masses of country people whose livelihood in the 1930s and early 1940s had been devastated by the woes of the Great Depression left their family farms in southeast Alabama and headed for the textile communities of Columbus and the other mill towns to the north. Although many were to gain employment as operatives in the weave sheds and spinning mills along the falls of the Chattahoochee, they were left speaking wistfully of such places as Dothan, Headland, Abbeville, and the other Alabama farming communities they had left behind, now referred to collectively by them as "down home." Their heads and bodies may have been relocated to Columbus, but their hearts surely remained in the rural countryside of southeastern Alabama. A ballad written by John James of Fort Mitchell, Alabama, echoes their sentiments:

THE BROWN LUNG BLUES
I left Pike County, Alabama, in the year of '33,
Struck out for Columbus, Georgia, as broke as I could be.
I walked the streets of Columbus, 'til I wore out a pair of shoes;
That's when I first got those ol' cotton mill blues.
 I've got a brown-lung condition and the cotton mill blues.
Well, th' boss down at the cotton mill said, "Boy, we could use you.
Twenty-eight dollars ever' two weeks you'll have due."
I said I would take it, and that was my bad news;
That's when I got those old cotton mill blues.
 I've got a brown-lung condition and the cotton mill blues.

Others, mainly African-Americans who had suffered the pangs of racial discrimination that were so pervasive throughout the segregated South, left the region altogether and headed away as far as they could go, hoping for new and equal opportunities in the industrial cities of the north and mid-

west. During the 1930s, the 1940s, and through the 1950s, thousands upon thousands of black families and individuals moved from here to Chicago, Detroit, Boston, New York, and Washington, D.C. Some of them cut their bonds with the South entirely, but others, especially those whose family members were left behind, remained in close contact with the South through letters to relatives, frequent phone calls, and annual visits back home. Many times older siblings and their parents would encourage younger brothers and sisters to get away for work or an education before they too became entrenched in the bonds of the segregated society.

The following obituary, which appeared in the March 23, 1993, edition of the *Columbus Enquirer* illustrates perfectly how very scattered traditional black Southern families could become as time passed:

Omaha, Ga.—*Anderson Walton, 88, died Monday at Hamilton House Nursing Home, Columbus. Funeral arrangements will be announced by Community Funeral Home, Lumpkin, Georgia. Mr. Walton was born July 10, 1904, in Stewart County, the son of Malachi and Amanda Walton. He was retired as a farmer and was a member of Mt. Moriah Baptist Church, Omaha . Survivors include his wife, Naomi; three brothers, James Edward Walton of Jersey City, N. J., George Aaron Walton of Los Angeles and William M. Walton of Omaha; three sisters, Amanda W. Smith of Pittsburgh, Margaret S. Hart of Atlanta and Eugenia L. Crayton of Cleveland, Ohio; and a stepsister, Alverda Draper of Sacramento, Calif.*

(from *The Columbus Ledger-Enquirer*, Columbus, Georgia, Tuesday, March 23, 1993)

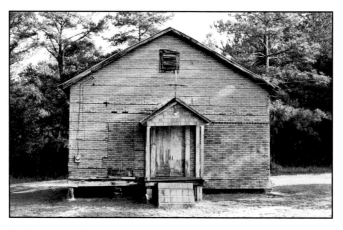

The Bethel A.M.E.Church, located in highway 26, between Cusseta and Buena Vista, Georgia

Bethel A. M. E. Church, detail showing the handmade cross over the front door

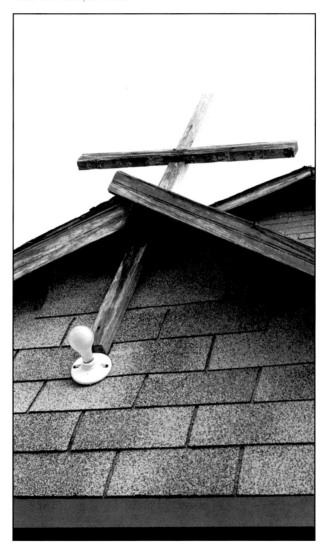

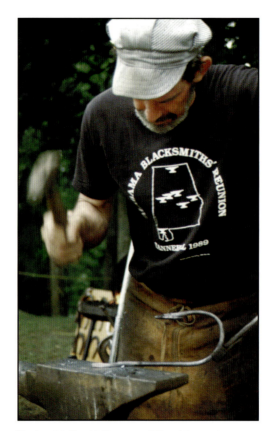

Blacksmith David Cornett of Pine Mountain, Georgia, forges a large iron hook at the Festival of Southern Cultures at Columbus State University, 1998.

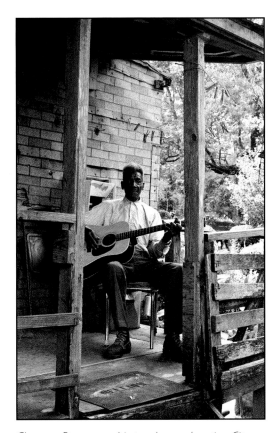

Clarence Persons on his porch near Junction City,
Georgia. Mr. Persons played and sang a variety of
old blues songs and ballads including John Henry
and K.C. Jones.

Cultural Diversity

Here in the late 20th century the cultural composition of the Lower Chattahoochee Valley region is nearly as diverse as it must have been in the years immediately before the Indian removal of the 1830s. During that time, the streets of Columbus would have been filled with a medley of voices speaking dialects of Spanish, German, Yiddish, Greek, French, Muscogee Creek, Choctaw, Yuchi, and a dozen or more assortments of English, revealing ancestral origins in West Africa, Ireland, the West Indies, Scotland, New England, and Virginia.

During the decades beginning just before the American Civil War and continuing through the 1930s, regional culture in the Chattahoochee Valley slowly polarized into two major components, nearly to the exclusion of all others. The population became almost evenly divided between Anglo American and African American citizens.

Even though the predominant cultural components in the region today remain about evenly split between black and white, the decades following the two World Wars and the Korean Conflict brought immigrants in substantial numbers into the region from Europe and Asia—particularly from Germany, France, and Russia, and from Korea, Cambodia, China, Vietnam, Japan, and Thailand—and later from the Caribbean, Mexico, and Latin America.

Much of the influx of immigrants into the Chattahoochee Valley region during the mid to late 20th Century was due to the significant presence of two major military bases in the region—Fort Benning in Georgia, and Fort Rucker in Alabama. Now, following nearly a century of social and racial symmetry, the Chattahoochee Valley is once again a place of complex cultural diversity.

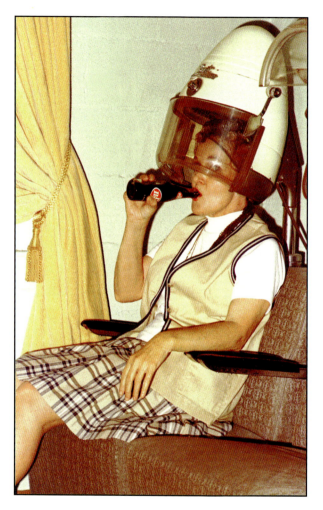

Beauty shop, Lumpkin, Georgia

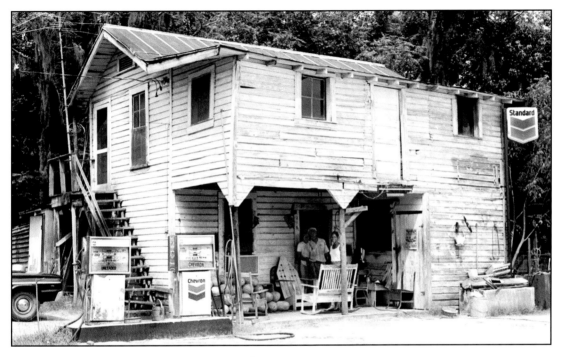

A roadside store and filling station, Clay County, Georgia

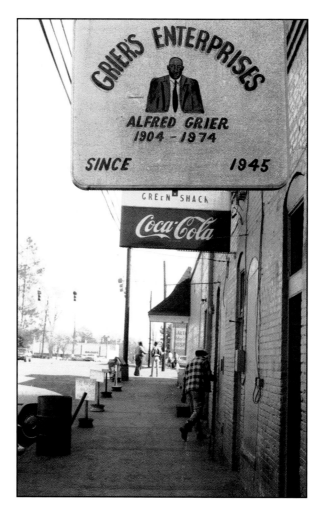

A street scene at Grier's Store, Dawson, Georgia

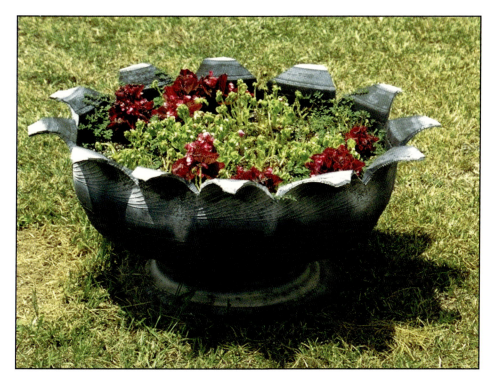

There are seemingly endless traditional ways of decorating yards in the Chattahoochee Valley region. One of the most popular, and one which appears in great variety, is the use of old automobile and tractor tires that have been painted and cut for use as planters, as edging for flower beds, or to define property lines.

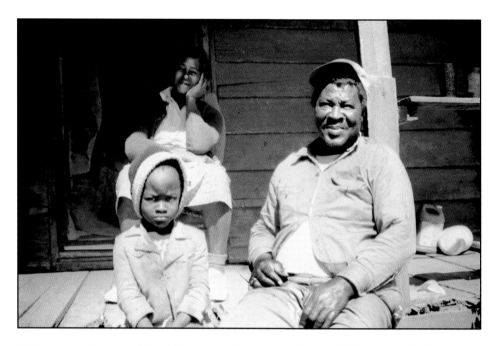

White oak basketmaker Gene Hill with his wife and grandson at their home on the Rood Plantation, Stewart County, Georgia, about 1975. Following the photo session during which this picture was made, Mr. Hill declared that "another man came here and made my picture one time, and I still have it." He then went into the house and soon returned with a battered 8" x 10" black and white print showing the young Gene Hill in very much the same position as you see him here. On the back of that photograph was the stamped imprint of the Farm Security Administration, a federal agency that sent photographers all around the country to document America's recovery from the Great Depression. The photo had been made by an F.S.A. Photographer in the late 1930s and Gene Hill had kept it as a personal memento through the intervening years.

Front porch of shape-note singer and song leader John Brown, Lumpkin, Georgia

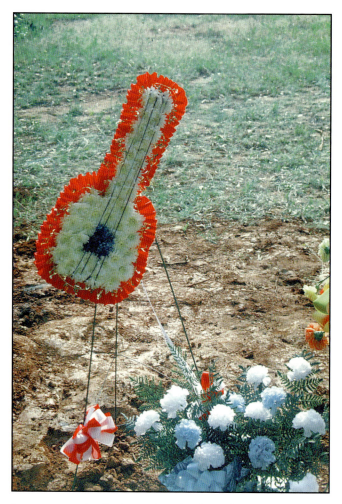

A commemorative floral wreath in the form of a guitar at the grave site of bluesman Albert Macon

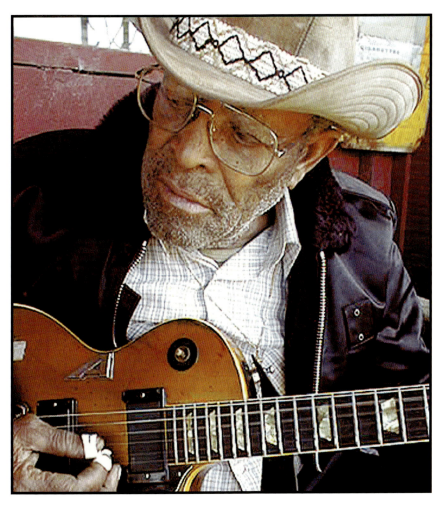

Bluesman George Daniel, Macon County, Alabama

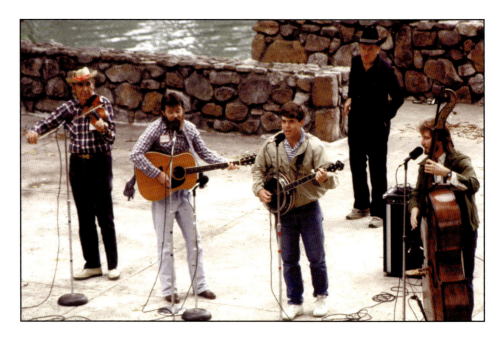

The Bluegrass Revue Band performing at the 1983 Chattahoochee Folk Festival in Columbus. The members of the group are (l.to r.) Gene Jackson, fiddle; Robert George, guitar; George Miles, banjo; and David Seckinger, bass. Standing behind the group is Buck Sewell, a player of the "Prince Albert banjo,"—an empty Prince Albert pipe tobacco can which Sewell would use to beat a rhythm on his fingers, his knees, his head, and his elbows.

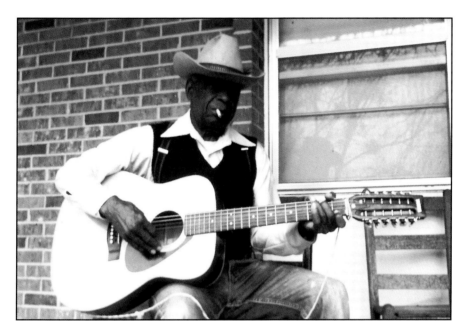

Bluesman J. W. Warren sits in front of his house in Ariton, Alabama. Warren was born and lived most of his life in or near Ariton. Ariton was also the birthplace of another famous blues player, "Big Mama" Thornton, who wrote "You Ain't Nothin' But a Houn' Dog", a song that was first recorded by her, but was later an early hit for Elvis Presley. Warren, who claims to have been sweethearts with "Big Mama," says that it is he who is the "Houn' Dog" in the song .

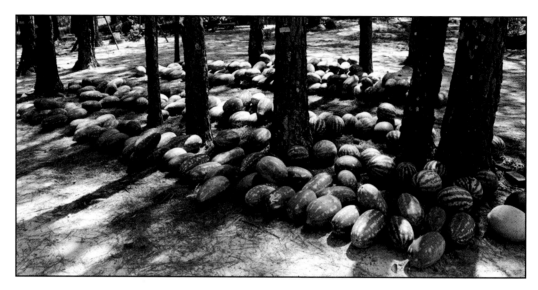

Watermelons lie cooling in the shade of a pine grove near a roadside market in Russell County, Alabama

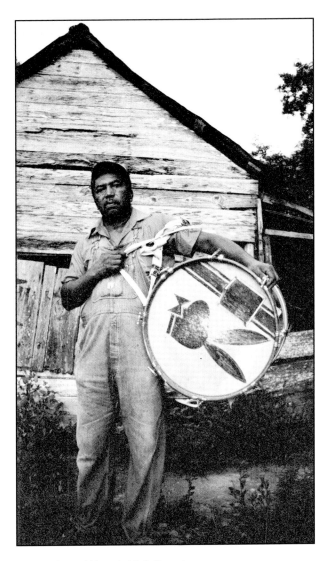

James Jones, Waverly Hall, Georgia

Home grown remedies and folk medicine remain an important aspect of traditional culture throughout the Chattahoochee Valley region. This sign, advertising the availability of yellow root and white dirt, was photographed at a convenience store in Luthersville, Georgia. Yellow root is a native wild plant. The roots of the plant, the inner bark of which is a brilliant yellow, are made into a tea that's used as a remedy for stomach problems. On occasion, a small portion of root is simply chewed by the patient. The taste of yellow root is extremely bitter. This plant was once the primary ingredient of a number of commercial patent medicines that were collectively referred to a "bitters."

White dirt can be any of several varieties of locally occurring natural clays that are dug directly from the earth. The choice clays are those that are extremely fine, stark white in color, and free of any sand or other foreign substances, such as pebbles or roots. The clay, or white dirt, is eaten as is by those who use it. Generally the user will eat a small, egg-sized portion of the dry clay following an otherwise normal meal. There are differing theories regarding the reasons that some people eat clay, but clearly one

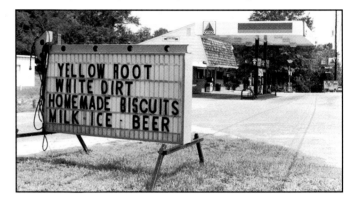

factor is cultural tradition. Some people say that they simply like the taste and texture while others report that a meal just seems to be incomplete to them unless they finish it off with a helping of white dirt. The practice remains quite popular and widespread in the Chattahoochee Valley and throughout the Deep South. White dirt is available, commercially labeled and packaged, at scores of retail outlets all around the Southeastern United States. When recently questioned with regard to what they intended to do with the clay they had just bought, several purchasers of clay at the Georgia State Farmer's Market in Columbus all answered that they intended to eat it. One lady stated that she regularly "has a little bite after every meal. It just seems to finish everything off to my satisfaction."

Earl Mims, who sells white clay at his business—E & M Produce Company—stated that he has now sold clay "for about eight or ten months." He gets it from local suppliers, who dig the clay locally, and from a company located in Forest Park, Georgia. Two clerks at the Baltimore Produce stand in Columbus listed the following possible uses for the white clay they sell: "to white wash rocks and tree trunks with it. But mostly people just eat it." One continued, "What I do is sell it. I don't generally ask people what they plan to do with it. I really don't have nothing negative to say about it. I just have it here 'cause there's such a high demand for it. People around here have always used it."

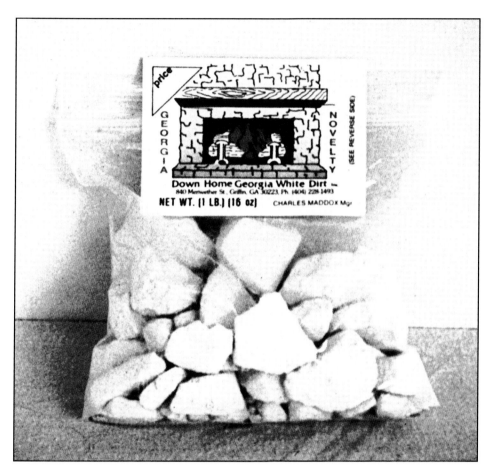

A commercially packaged and labelled sample of "Georgia White Dirt"

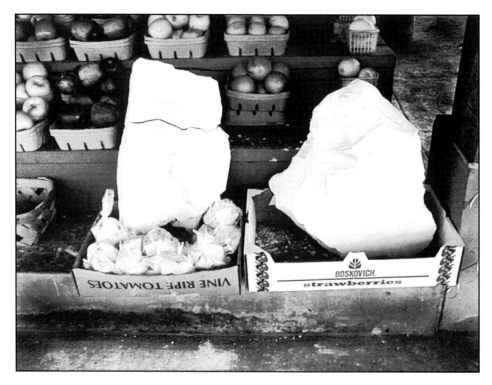

Large chunks of natural white dirt for sale at the Georgia State Farmer's Market, Columbus, Georgia.

Benevolence, Georgia

The Bedingfield Inn, Lumpkin, Georgia. This building was constructed on the Lumpkin town square in 1832 and was restored by the Stewart County Historical Society in the late 1960s.

A grave shelter, Barbour County, Alabama. Rural graveyards around the Chattahoochee Valley reveal many examples of traditional decorative devices that are used to express personal loss or to honor deceased relatives and friends. The origins of grave shelters such as this one in northern Barbour County, Alabama, are uncertain, but it is possible that they may lie in the historic Native American practice of burying deceased relatives directly in the floor of the family household.

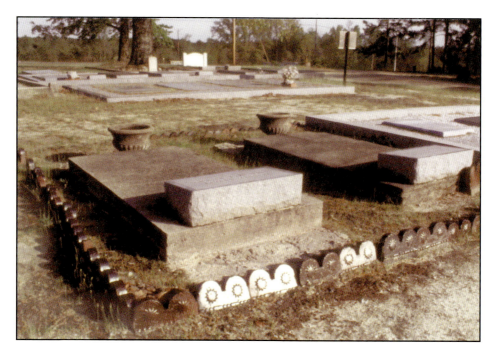

Locally manufactured decorative ceramic tiles are frequently used throughout the region to define the borders of cemetery lots and grave plots, especially in the rural areas. Other borders are typically made of ceramic or glass bottles, common bricks, glass jars, white painted stones, or painted fragments of broken concrete.

Lumpkin, Georgia

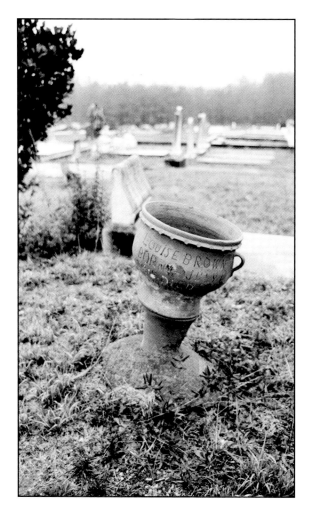

A hand-turned stoneware grave marker

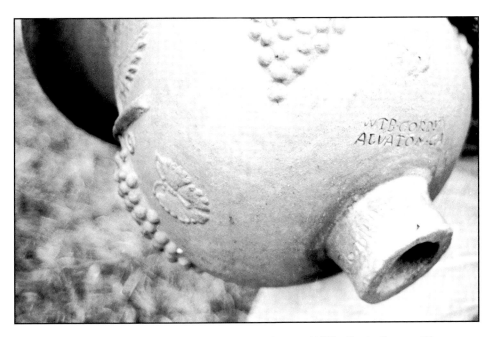

Detail: stoneware grave marker showing the mark of potter W.T.B. Gordy, Alvaton, GA.

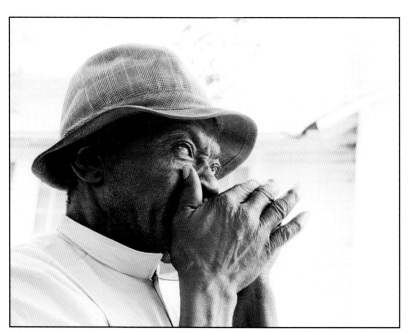

Harp blower Golden Bailey .

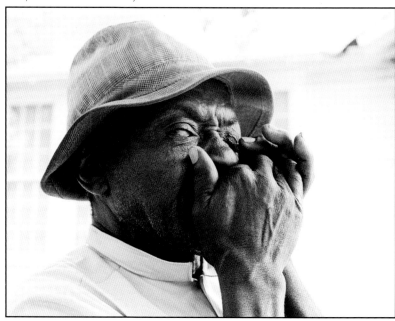

Harmonica player Golden Bailey in his Talbot County, Georgia, front yard. Golden Bailey, pictured here, lived in a little house just west of Geneva, Georgia, on the edge of an area which could (and still can) boast of an inordinate population of traditional musicians. If you draw a line from Geneva to Talbotton, and then another line from Talbotton to Waverly Hall, and then draw a third one back to Geneva, then within the resulting triangle there can scarcely be found a person who is not a traditional musician of one kind or another, except for those who have moved in there during the last fifteen years. Notable among the musicians of the area are James Jones, a buckdancer who was also the drummer and leader of a rare group of African-American fife and drum players, and his cousin, Precious Bryant, who was one of the finest female blues players in the entire nation. Precious Bryant's mentors were her uncle, Lonnie James Bussey, and her father, George Henry Bussey. Her son, Tony is a skilled bassist, and her five sisters are all gifted gospel singers. There are many, many other traditional musicians in the area. Golden Bailey was a fine and entertaining harp blower. His renditions of hound dogs chasing a possum on the hunt, or the sounds of a freight train passing in the night were unmistakable. Mr. Bailey attributed his ability to blow the harmonica for long periods of time without stopping to this: "Just eat a little bite of raw biscuit dough every day," he said, "that builds up your breath like nothing else."

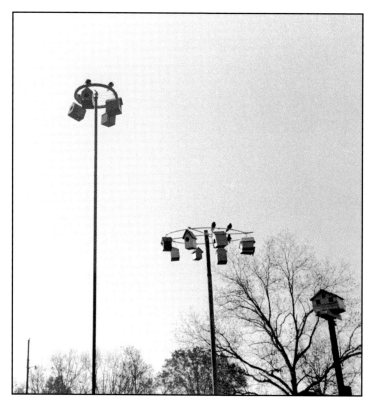

Purple Martin houses, Henry County, Alabama. The use of bird houses perched high on poles to attract insect eating Purple Martins is perhaps one of the oldest traditions in the South. There is evidence that the prehistoric Indians of the region used gourds in just this way and for the same purpose. Gourd "trees" and other assemblages of gourds placed in farm yards around the area have become so commonplace and numerous that their presence has become a virtual icon of traditional culture in the Deep South.

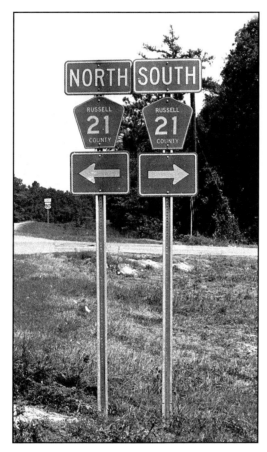

*The intersection of U.S. Highway 80 and County
Road 21, Russell County, Alabama*

A rainy day, Lumpkin, Georgia

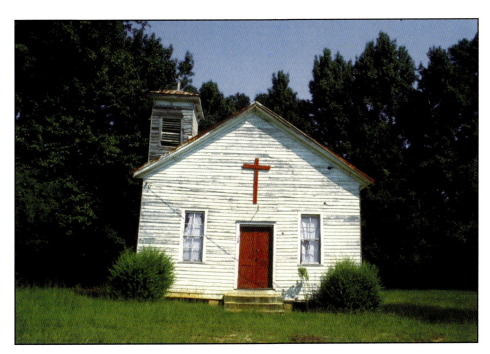

Stewart County, Georgia

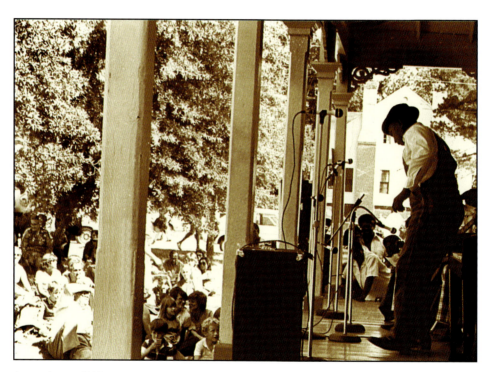

James Jones of Waverly Hall, Georgia, demonstrates buck dancing at the 1993 Chattahoochee Folk Festival.

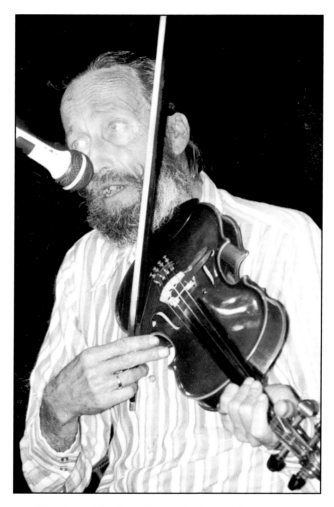

Traditional musician Doug Booth, Dothan, Alabama.

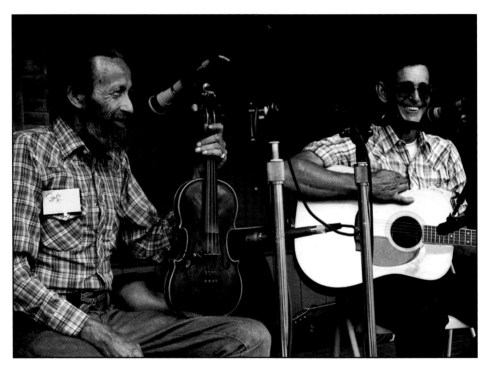

Doug Booth and Joe Berry, both of Dothan, performing at the 1992 World's Fair, Knoxville, Tennessee.

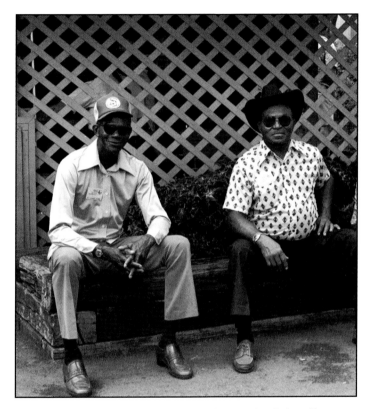

The Macon County, Alabama, blues and boogie duo, Robert Thomas and Albert Macon at the 1992 World's Fair, Knoxville, Tennessee

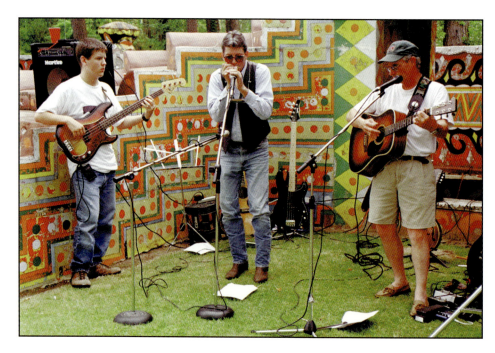

The popular Phenix City-Columbus singer/songwriter group known as "The Dillinghams" performing at St. EOM's Pasaquan in 1998. They are, left to right, Jake Fussell, Henry Parker, and Rick Edwards

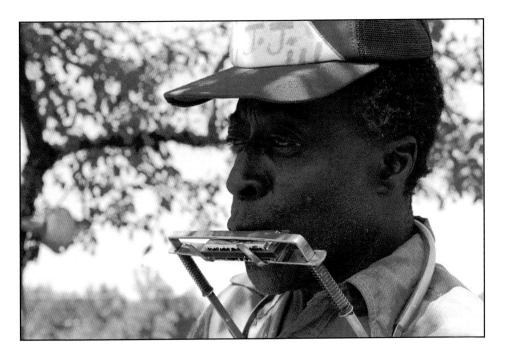

Bluesman McKinley James of Notasulga, Alabama. In the mid-1960s, McKinley James released a song titled "Tuskegee Boogie," which made its way onto the R&B charts for a number of weeks. James, who referred to himself as "Guitar-Harp Blues Boy McKinley James, the Thunderbolt of the East," was an energetic performer on harmonica, guitar, and as a vocalist.

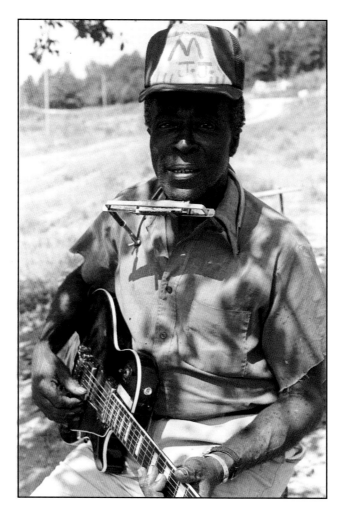

McKinley James: "The Thunderbolt of the East."

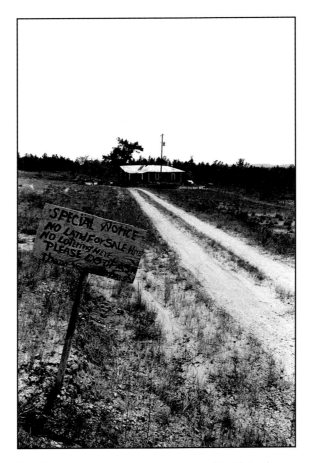

The dirt driveway leading to the home of McKinley James.
The sign reads:
 SPECIAL NOTICE
 NO LAND FOR SALE HERE
 NO LOTERING HERE
 PLEASE DO NOT ASK
 THANK YOU—BY MR McJ

Bluesman McKinley James was an avid squirrel hunter, but the death of his favorite squirrel dog in 1974 caused him to give up the sport forever. He buried his beloved hunting partner in a special grave in his backyard and decorated the site with stones and a half-gallon whiskey bottle. A tree was planted there in his memory. The marker reads:

 CLAWDY BOY
— born Dec-25 1960 —
— past-Oct-16-1974—
—squrriel wizard —
 A REAL DOG.

According to McKinley James, the black skull and x's that are painted on the sign are there to signify that "Clawdy Boy" was intentionally poisoned by someone unknown.

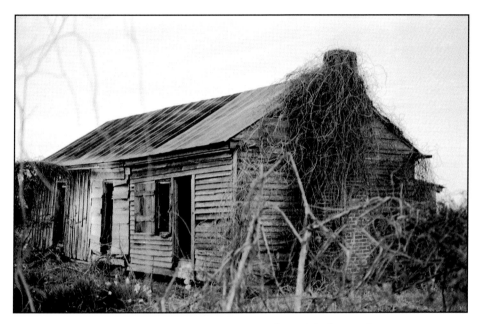

Winter kudzu on an abandoned sharecropper house, Randolph County, Georgia

Macon County, Alabama

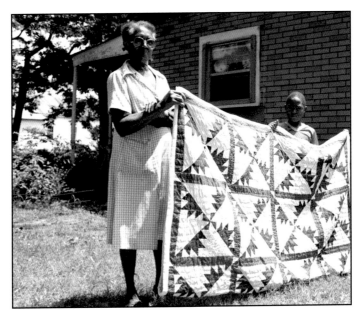

Quilter Jessie Telfair, Parrott, Georgia. Jessie Telfair is best known for her famous "Freedom" quilt, which she made in 1975 after witnessing several instances of violent racial conflict involving Freedom Riders in nearby Americus, Georgia. That quilt, now in the collection of Atlanta's High Museum of Art, is made of large simple blocks repeatedly spelling the word FREEDOM.

Index

Other Titles about the
Historic Chattahoochee Valley

**Chattahoochee Valley Sources and
Resources: An Annotated Bibliography**
Volume I—The Alabama Counties, edited by John Lupold
Volume II—The Georgia Counties, edited by John Lupold

**A Blockaded Family: Life in Southern
Alabama During the Civil War**
Parthenia Antoinette Hague

**Fair to Middlin':
The Antebellum Cotton Trade of the
Apalachicola / Chattahoochee River Valley**
Lynn Willoughby

**Flowing Through Time:
A History of the Lower Chattahoochee River**
Lynn Willoughby

**Clio, Alabama:
A History**
Alto Loftin Jackson

I Can Go Home Again
Arthur G. Powell

**In Celebration of a Legacy:
The Traditional Arts of the Lower
Chattahoochee Valley**
George Mitchell; Foreword by Fred Fussell

**Introduction and Index to the John Horry
Dent Farm Journals and Account Books,
1840–1892**
Ray Mathis and Mary Mathis

**John Horry Dent Farm Journals and
Account Books, 1840–1892**
*Ray Mathis, Mary Mathis, and Douglas Clare Purcell,
compilers/editors*

**Navy Gray:
Engineering the Confederate Navy on the
Chattahoochee and Apalachicola Rivers**
Maxine Turner

**Portrait of A Region:
A Pictorial Journal Along the Chattahoochee
Trace of Alabama and Georgia**
Compiled by the Historic Chattahoochee Commission

Rich Man's War:
Class, Caste, and Confederate Defeat
in the Lower Chattahoochee Valley
David Williams

The Federal Road Through Georgia,
The Creek Nation, and Alabama,
1806–1836
Henry DeLeon Southerland, Jr., and Jerry Elijah Brown

The Old Beloved Path:
Daily Life Among the Indians of the
Chattahoochee River Valley
William W. Winn

The Riverkeeper's Guide to the
Chattahoochee
Fred Brown and Sherri M.L. Smith

The Very Worst Road:
Travellers' Accounts of Crossing
Alabama's Old Creek Indian Territory,
1820–1847
Compiled by Jeffrey C. Benton

This So Remote Frontier:
The Chattahoochee Country of
Alabama and Georgia
Mark Fretwell

To Remember a Vanishing World:
D.L. Hightower's Photographs of
Barbour County, Alabama, c. 1930–1965
Michael V.R. Thomason

River Song:
A Journey Down the Chattahoochee
and Apalachicola Rivers
Joe and Monica Cook

Perilous Journeys:
A History of Steamboating on the
Chatta-hoochee, Apalachicola, and
Flint Rivers, 1828–1928
Edward A. Mueller

A Heritage Education Unit on the
Homes of the Chattahoochee Trace
Maurie Van Buren

For further information, or to order these titles,
please contact:
The Historic Chattahoochee Commission
P.O. Box 33, Eufaula, AL 36072-0033
(334) 687-9755
or visit our web site:
www.hcc-al-ga.org